OFFICIAL SQA PAST PAPERS WITH SQA ANSWERS

Higher
ENGLISH AND COMMUNICATION

Higher Grade 1998 to 1999, and Higher Still Specimen Question Paper, 2000 and 2001 with three years' answers

© Copyright Scottish Qualifications Authority

First exam published in 1998.

Published by
Leckie & Leckie Ltd, 8 Whitehill Terrace, St. Andrews, Scotland KY16 8RN
tel: 01334 475656 fax: 01334 477392
hq@leckieandleckie.co.uk www.leckieandleckie.co.uk

Leckie & Leckie Project Management Team: Tom Davie; David Nicoll; Bruce Ryan
Cover Design Assistance: Mike Middleton

ISBN 1-898890-74-9

A CIP Catalogue record for this book is available from the British Library.

Printed in Scotland by Inglis Allen on environmentally friendly paper. The paper is made from a mixture of sawmill waste, forest thinnings and wood from sustainable forests.

® Leckie & Leckie is a registered trademark.

INVESTOR IN PEOPLE Leckie & Leckie Ltd achieved the Investors in People Standard in 1999.

Leckie & Leckie

Introduction

The best way to prepare for exams is to practise, again and again, all that you have learned over the past year. Work through these questions and check your solutions against these *official SQA answers*. But give yourself a real chance and be honest! Make sure you work through each question thoroughly so that you understand how you got the right answer – *you will have to do this in the exam*!

Although the 1998 and 1999 Papers cover the old Higher Grade exam, you will still find them useful for your Higher Still revision.

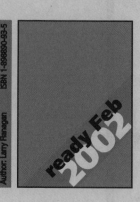

Leckie & Leckie's Intermediate 2 and Higher English Course Notes
Develop selective reading skills and greater structure within your essays with this innovative course leader. Guidance on how to approach every aspect of the syllabus, including discussion, provides stimulating support throughout.

Contents

Leckie & Leckie has made every effort to trace all copyright holders. If any have been inadvertently overlooked, Leckie & Leckie will be pleased to make the necessary arrangements. Leckie & Leckie would like to thank the following for their permission to reproduce their material:

Mainstream Publishing for an extract from *Surviving the Shipwreck* by William McIlvanney (p 76),
Extract from *I'm a little special – a Muhammed Ali reader* by Gerald Early published by Yellow Jersey Press. Used by permission of the Random House Group Limited (p 99),
Originally is taken from *The Other Country* by Carol Ann Duffy published by Anvil Press Poetry in 1990 (p 102).

0860/201

SCOTTISH
CERTIFICATE OF
EDUCATION
1998

TUESDAY, 5 MAY
9.15 AM – 11.20 AM

ENGLISH
HIGHER GRADE
Paper I

There are **two parts** to this paper, Part 1 (Interpretation) and Part 2 (Report). You should attempt both parts.

Part 1 (Interpretation), on pages 2, 3 and 4, is worth 40 marks. There are two passages, with questions following. Use the left-hand margin of the answer book to indicate clearly the questions attempted.

Part 2 (Report), on pages 6, 7 and 8, is worth 35 marks. You should begin your Report on a fresh page of the answer book.

PART 1—INTERPRETATION

Attempt all of Part 1. You should spend approximately 1 hour on this part of the paper, including reading time. There are TWO passages and questions.

Read both passages carefully and then answer all the questions which follow on page four. **Use your own words whenever possible and particularly when you are instructed to do so.** The number of marks attached to each question will give some indication of the kind of answer required.

It is important that you read both passages before you attempt to answer any of the questions.

The first passage, by the distinguished and controversial journalist, John Pilger, appeared in a national newspaper in 1991. The second passage is an extract from Joseph Conrad's short story, "An Outpost of Progress", which was written in the 1890s.

PASSAGE 1

INFORMATION IS POWER

On the day that media tycoon Robert Maxwell died, an estimated 6,000 people were killed in a typhoon in the Philippines, most of them in one town. Maxwell's death dominated the British
5 media. It made an intriguing story, with few facts. Speculation and offerings by former retainers were unrelenting. His yacht was described in all its opulent detail; there was the bed the man had slept in and the crystal he and potentates had drunk
10 from. It was said that he consumed £60,000 worth of caviar in a year. And there was the man himself: in shorts, in shades, in a turban, with Elton John on the sports pages.

The death of the Filipinos, the equivalent of the
15 sudden extinction of a Welsh mining village, with many more children killed than at the Aberfan disaster in 1966, was mentioned in passing, if at all. On the BBC's *Nine O'Clock News* Maxwell was the first item; the disaster in the Philippines was one of
20 the last in a round-up of "fillers".

In one sense, the two events were connected. Maxwell embodied the new age of imperialist wealth: of triumphant rapacity based on asset-stripping, "off-shore" secrecies, and, above all,
25 money-making from debt. The people who were swept to their deaths at Ormoc on the island of Leyte were also part of the new age. In an area of no previous experience of natural calamity, most of them died in flooding and mud slides that may well
30 have been the result of deforestation. "It's a man-made disaster abetted by nature," said Leyte's governor.

With almost half their national budget committed to paying the interest on debt owed to the World
35 Bank, the International Monetary Fund (IMF) and Western commercial banks, Filipinos are raping their beautiful country in order to export anything that brings in dollars and yen. Coral reefs are poisoned with cyanide to provide goldfish for
40 the goldfish bowls of America. Forests are illegally logged to satisfy a Japan long ago stripped of trees.

This is not news, just as the deaths of the victims are, at most, news of minor importance. "Small earthquake: not many dead" is not quite the joke it used to be. Natural disasters in the Third World 45 are reported; it is the manner of the reporting, and the subtext, that helps to secure for the majority of humanity the marginal place the world's media allots them. A typhoon, an earthquake, a war: and they are news of a fleeting kind, emerging solely as 50 victims, accepting passively their predicament as a precondition for Western acknowledgement and charity.

Consider the strictly controlled Western perspective of Africa. The fact that Africa's 55 recurring famines and extreme poverty have political causes rooted in the West is not regarded as news. How many of us were aware during 1985—the year of the Ethiopian famine and of "Live Aid"—that the hungriest countries in Africa 60 gave twice as much money to *us* in the West as we gave to them: billions of dollars to our banks and finance houses just in interest payments on national debt?

We were shown terrible television pictures of 65 children dying and we were not told of the part our financial institutions had played in their deaths. This also was not news. The camera was allowed to dictate a false neutrality, as is often the case, with the reporter playing the role of concerned innocent 70 bystander and caption writer. This "neutrality" is commonly known, with unintended irony, as "objectivity". Yet in truth, it merely reinforces the West's beloved stereotype of Third World dependence. 75

This was illustrated when a group of London schoolchildren was asked for views of the Third World: several of them wrote, "Hell". None of them could provide a coherent picture of actual people. The majority of humanity are not 80 news, merely mute and incompetent stick figures that flit across the television screen. They do not

argue or fight back. They are not brave. They do not have vision. They do not conceive models of
85 development that suit *them*. They do not form community and other grass-roots organisations that seek to surmount the obstacles to a better life.

Never in the Western media is there a celebration of the survival, the resourcefulness and humanity of those who live in the Third World; nowhere is 90 there mention of the generosity of the poorest, of the capacity for altruism of those who have nothing, of the wisdom, endurance and tenacity of people displaced from forests, hills or pastures by western-inspired patterns of development. 95

(John Pilger)

PASSAGE 2

AN OUTPOST OF PROGRESS

Kayerts and Carlier lived like blind men in a large room, aware only of what came in contact with them (and of that only imperfectly), but unable to see the general aspect of things. The river, the
5 forest, all the great land throbbing with life, were like a great emptiness. Even the brilliant sunshine disclosed nothing intelligible. Things appeared and disappeared before their eyes in an unconnected and aimless kind of way. The river
10 seemed to come from nowhere and go nowhither. It flowed through a void.

Out of that void, at times, came canoes, and men with spears in their hands would suddenly crowd the yard of the trading post. They were naked,
15 glossy black, ornamented with snowy shells and glistening brass wire, perfect of limb. They made an uncouth babbling noise when they spoke, moved in a stately manner, and sent quick, wild glances out of their startled, never-resting eyes.
20 Those warriors would squat in long rows, four or more deep, before the verandah, while their chiefs bargained for hours with Makola over an elephant tusk.

Kayerts sat on his chair and looked down on the
25 proceedings, understanding nothing. He stared at them with his round blue eyes, called out to Carlier, "Here, look! look at that fellow there—and that other one, to the left. Did you ever see such a face? Oh, the funny brute!"

30 Carlier, smoking native tobacco in a short wooden pipe, would swagger up twirling his moustaches, and surveying the warriors with haughty indulgence, would say—

"Fine animals. Brought any ivory? Yes? It's not
35 any too soon. Look at the muscles of that fellow— third from the end. I wouldn't care to get a punch on the nose from him. Fine arms, but legs no good below the knee. Couldn't make cavalry men of them." And after glancing down complacently at his own shanks, he always concluded: "Pah! Don't 40 they stink! You, Makola! Take that herd over to the storehouse and give them up some of the rubbish you keep there. I'd rather see it full of ivory than full of rags."

Kayerts approved. 45

Such profitable visits were rare. For days the two pioneers of trade and progress would look on their empty courtyard in the vibrating brilliance of vertical sunshine. Below the high bank, the silent river flowed on glittering and steady. On the sands 50 in the middle of the stream, hippos and alligators sunned themselves side by side. And stretching away in all directions, surrounding the insignificant cleared spot of the trading post, immense forests, hiding fateful complications of 55 fantastic life, lay in the eloquent silence of mute greatness. The two men understood nothing, cared for nothing but for the passage of days that separated them from the steamer's return.

Their predecessor had left some torn books. They 60 also found some old copies of a home newspaper. That print discussed what it was pleased to call "Our Colonial Expansion" in high-flown language. It spoke much of the rights and duties of civilisation, of the sacredness of the civilising 65 work, and extolled the merits of those who went about bringing light, and faith and commerce to the dark places of the earth. Carlier and Kayerts read, wondered, and began to think better of themselves. Carlier said one evening, waving his 70 hand about, "In a hundred years, there will perhaps be a town here. Quays, and warehouses, and barracks, and—and—billiard-rooms. Civilisation, my boy, and virtue—and all. And then, chaps will read that two good fellows, Kayerts and Carlier, 75 were the first civilised men to live in this very spot!" Kayerts nodded, "Yes, it is a consolation to think of that."

(Joseph Conrad)

QUESTIONS FOR PART 1—INTERPRETATION

Questions on Passage 1

Marks

(a) (i) By referring to a word or phrase in paragraph 1 (lines 1–13), explain what is suggested about Robert Maxwell's lifestyle.

 2

 (ii) What is John Pilger's view about the reporting of Robert Maxwell's death and the reporting of the deaths in the Philippines?

 1

 (iii) By referring to paragraph 2 (lines 14–20), show how Pilger conveys his view.

 2

(b) "In one sense, the two events were connected." (line 21)

By referring to lines 22–41, explain the writer's view that there is a link between Maxwell and the deaths of the 6,000 Filipinos.

 2

(c) What "subtext" (underlying message) is referred to in line 47? You should refer to the next sentence. ("A typhoon, an earthquake . . . and charity.") in your answer.

 2

(d) (i) Show how the information in parenthesis (lines 59–60) contributes to Pilger's argument at this stage.

 2

 (ii) In your own words, explain fully how, according to Pilger, television presented a "false neutrality" (line 69) in its coverage of the Ethiopian famine.

 3

 (iii) Comment on the tone of "the West's beloved stereotype of Third World dependence" (lines 73–75).

 2

(e) "This was illustrated when . . . wrote, 'Hell'." (lines 76–78)

Show how this sentence acts as a link between the two paragraphs.

 2

(f) "The majority of humanity . . . flit across the television screen." (lines 80–82)

Show how Pilger's word choice in this sentence conveys his view about the Western media's representation of the Third World.

 3

(g) By referring to lines 88–95, show how Pilger creates a climax to the passage. (In your answer, you may wish to refer to sentence structure, word choice, rhythm, ideas . . .)

 4

 (25)

Questions on Passage 2

(h) By referring to lines 1–19 (". . . never resting eyes."), show how Joseph Conrad develops the simile, "Kayerts and Carlier lived like blind men in a large room" (lines 1–2).

 3

(i) Show how the words spoken in lines 27–44 reveal each man's racism.

 2

(j) By commenting on particular words or phrases in lines 46–59, show how the author contrasts the trading post with its surrounding landscape.

 2

(k) (i) Show how the context helps you to arrive at the meaning of "high-flown language". (lines 63–64)

 2

 (ii) Explain the irony of Carlier's words "In a hundred years . . . in this very spot!" (lines 71–77)

 2

 (11)

Question on Both Passages

(l) Joseph Conrad's short story about two Europeans living in Africa was written and is set in the 1890s; John Pilger is writing about the Third World and the West some 100 years later.

To what extent do these passages show that Western attitudes towards the Third World and its people have altered in this time? You should refer closely to both passages in your answer.

 4

 (4)

 Total (40)

[Part 2 (Report) is on Pages 6, 7 and 8

[Turn over for Part 2 (Report)]

PART 2—REPORT

READ THE INSTRUCTIONS BEFORE YOU ATTEMPT THIS QUESTION

(i) *The Millennium Commission—some information*

The Millennium Commission was set up by the government in 1994 to prepare plans for national celebrations of the millennium. It will receive 20% of the proceeds of the National Lottery until 31 December 2000. It is funded entirely through the proceeds of the Lottery. Camelot plc, the Lottery organiser, estimates that the Commission's income by the end of the year 2000 may reach £1·6 billion.

The Commission offers grants to three types of project:

Capital projects—around a dozen major "landmark" projects: "umbrella" applications, which group together smaller schemes with a common theme. Around £800 m will be available.

Millennium Awards—grants to hundreds of groups and individuals; £20 m available each year until 2000.

Millennium Exhibition and Festival
An Exhibition on the theme of Time will be sited on the Greenwich Peninsula in South East London (up to £200 m available); there is also to be a programme which will culminate in each part of the UK "owning" a week of the Exhibition.

Capital projects (in Scotland) include:

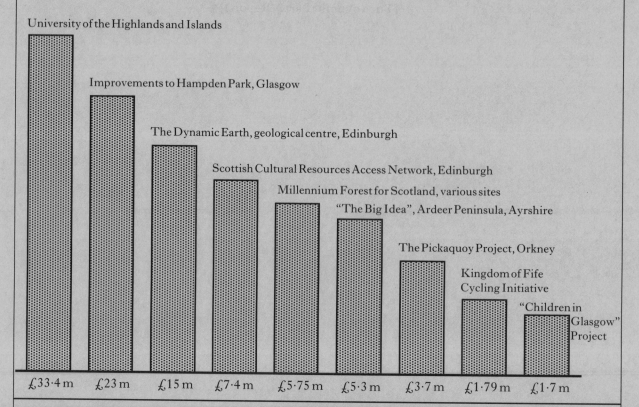

Michael O'Connor, Director of Policy and Corporate Affairs at the Millennium Commission, explains: "The Commissions's funding strategy encompasses large and small capital projects, national celebrations and empowering individuals to make a contribution to the community. Together, these grant programmes extend opportunities to celebrate the millennium to communities across the UK."

READ THIS SECTION BEFORE YOU ATTEMPT THE QUESTION

THE MILLENNIUM

The items on pages 6, 7 and 8 relate to the topic of the "Millennium". Read them carefully.

You should spend approximately one hour on this part of the paper, which is worth 35 marks.

Your task is to write a report on the topic of the Millennium by selecting relevant information and reorganising the material provided. You might find it helpful to consider the following:

(a) why the millennium may be significant and plans already made to celebrate it;

(b) problems or controversies surrounding the millennium;

(c) benefits which may result from the celebration of the millennium.

You must base your report entirely on the material presented to you, and on any direct inferences you can draw from it. You should use your own words as far as possible. You should take an objective point of view. Write your report in formal, continuous prose. You are likely to be able to complete this task in about 400 words, but there is no penalty for exceeding the length.

(ii) *A personal view—Robert Tremayne*

"Who will buy this wonderful morning...?"

There are at least three main issues in relation to the Millennium which concern me greatly.

To begin with, the date is quite arbitrary. The birth of Christ has been estimated by a variety of authorities as having taken place at any time up to 4 BC (as we call these years in present form). We may therefore have already passed the "true" millennium.

Secondly, the entire Chinese and Muslim worlds, up to three quarters of the population of the world, employ a different numbering system. The Muslim calendar has the year 2000 as its year 1421, and our year 2000 is, for the Chinese, simply the Year of the Dragon.

Further, the importance of the millennium as a significant point in world history (if indeed it is) has been hi-jacked by commercial concerns which want to get a jump ahead of their rivals. Already one Japanese car manufacturer has—it seems—"bought the rights" to the first sunrise of the year 2000. This will take place on the Chatham Islands, in the Pacific Ocean, close to the International Date Line, and the inhabitants have auctioned off the opportunity to record the arrival of the first rays of the sun on 1st January in the year 2000. Other reports suggest that already the greater part of the world's finest champagne has been bought up and stored away for consumption (only by the very rich, of course) at the millennium, while hotels—particularly in Scotland, which seems to have the world rights to New Year (Hogmanay) celebrations—and cruise companies report massive increases in advance bookings for the start of the next millennium.

For these reasons, then, it seems to be quite foolish to get excited by the turning of billions of second, minute and hour hands on billions of the world's clocks as they signify our movement from one not-very-special day to another. Indeed, maybe we should just pay more attention to the here and now, to the impoverished, the destitute, the homeless, those for whom there is at present little or no future, before concerning ourselves with another excuse for another celebration which is at best in bad taste, and at worst is an insult to those who have no part to play in it.

(iii) *A definition*

> A millennium is a period of 1,000 years. Some Christian sects believe that Jesus will return to govern the Earth in person at the next millennium.

(iv) *Some problems relating to the Millennium*

Every computer has a built-in clock, which also automatically keeps a note of the date. Until recently, date information on computers was limited to two digits in order to save space. As a result, 1986 was recorded as 86, 1997 as 97, and so on. The problem arises when we enter the year 2000: it becomes 00—which simply means nothing, an emptiness, a void, and many systems cannot cope with such a concept. Worse still, for some companies, bills will go unpaid, because they appear never to fall due; old stock is not used because it appears to be younger than newer stock or it appears not to exist at all, and service and maintenance schedules are turned upside down.

The cost to businesses worldwide could be in the region of $600 billion.

To mark the passing of an hour, you begin counting at 00.00; then one minute later will be 00.01, and so on until you reach 00.59. The hour is complete one minute later at 01.00. In the same way, then, the **century** is only complete at the **end** of the year 100, when we begin the year 101. Try it yourself—count from year 0 A.D. (the birth of Christ) and one year is up at the moment we reach year 1 A.D. So, a century is up at the **end** of the year 100, at the beginning of the year 101. To be correct, then, celebrations for the millennium should take place at the **end** of the year 2000, in 2001, not at the end of 1999, as most people are planning to do.

(v) *A personal view—P. Robinson*

AN OPPORTUNITY FOR RENEWAL

Why shouldn't the year 2000 be significant? The mathematics do not really matter—whether the millennium ends at the beginning or at the end of the year 2000. That number—2000—has a resonance, a ring to it, that few other numbers possess. It has a significance which spreads worldwide, which other dates cannot match, and because of this its arrival will be celebrated all over the world by hundreds of millions of people. It is therefore a unifying force; it contributes to international feeling and provides a common focus, maybe even a common purpose, for all the people of the world.

While every January provides an opportunity for individuals to think of what they are doing and where they are going, to renew themselves, maybe even re-invent themselves, the first January of the year 2000, the first month, year and decade of the next millennium will provide a special opportunity for the world as a whole to assess where it is going. We will have a unique chance to wipe the slate clean and re-dedicate ourselves to the future. Only once in a thousand years is a generation lucky enough to be able to mark, so dramatically, the passing of the old and the arrival of the new. It is to be hoped, then, that some world leaders will emerge who will provide the inspiration, the vision, to lift our eyes from mere champagne celebrations and look forward to the new era with hope for the future for all.

[END OF QUESTION PAPER]

0860/202

SCOTTISH
CERTIFICATE OF
EDUCATION
1998

TUESDAY, 5 MAY
1.00 PM – 2.35 PM

ENGLISH
HIGHER GRADE
Paper II

There are **two parts** to this paper and you should attempt both parts.

In Part 1, you should attempt **either** Section A (Practical Criticism) **or** Section B (Close Reading of Specified Texts).

In Section A there are two optional questions for Practical Criticism. If you choose Section A, attempt only one of the two Practical Criticism questions.

In Section B there are nine optional questions on Specified Texts. If you choose Section B, attempt only one of the nine Specified Texts questions.

Each option in Part 1 is worth 25 marks.

In Part 2 (Critical Essay), you should attempt **one** question only, taken from any of the Sections A–D.

Your answer to Part 2 should begin on a fresh page.

Each question in Part 2 is worth 30 marks.

NB You must not use, in any part of this paper, the same text(s) as you have used in your Review of Personal Reading.

You must also pay attention to the instruction at the top of each Section in Part 2 about the use of genres and specified texts.

Index of Specified Texts/Authors in Part 1 Section B

SCOTTISH
QUALIFICATIONS
AUTHORITY

PART 1

You should spend approximately 45 minutes on this part of the paper.

SECTION A—PRACTICAL CRITICISM

If you choose this Section, attempt <u>either</u> Option 1 below <u>or</u> Option 2, which begins on Page four.

Option 1

Enter the letter corresponding to each question in the left-hand margin of your answer book.

Read the poem carefully and answer the questions which follow on **Page three**.

FARMER'S DEATH

Ke-uk, ke-uk, ke-uk, ki-kwaik,
The broon hens keckle and bouk,
And syne wi' their yalla beaks
For the reid worms houk.

 5 The muckle white pig at the tail
O' the midden slotters and slorps,
But the auld ferm hoose is lown
And wae as a corpse.

The hen's een glitter like gless
10 As the worms gang twirlin' in,
But there's never a move in by
And the windas are blin'.

Feathers turn fire i' the licht,
The pig's doup skinkles like siller,
15 But the auld ferm hoose is waugh
Wi' the daith intill her.

Hen's cries are a panash in Heaven,
And a pig has the warld at its feet;
But wae for the hoose whaur a buirdly man
20 Crines in a windin' sheet.

Hugh MacDiarmid

Marks

(a) Show how the poet uses sound in lines 1–2 and lines 5–6 to portray hens and the pig respectively. 4

(b) What contrast is made between the farmyard and the farmhouse in lines 1–8? 2

(c) What impression are you given of the hen by the imagery and word choice of lines 9–10?
You should explain fully how this impression is given. 4

(d) In lines 13–14 and lines 17–18, you are given further descriptions of both the hen and the pig. By close reference to the language of these lines, state what development in the significance of these animals you can detect. 4

(e) By referring to the description of the farmhouse throughout the poem, show how the poet creates a particular mood. You should refer to three poetic techniques such as word choice, structure, sound, repetition, imagery. 6

(f) How does the verse form enhance the impact of the poem? You may wish to refer to such features as structure, sound, syntax . . . 2

(g) Does the poet's use of humour seem to you to add to or detract from the emotion of the poem? You should refer closely to the text in your answer. 3

(25)

[SECTION A—Option 2 starts on Page four

SECTION A—PRACTICAL CRITICISM (continued)

Option 2

Enter the letter corresponding to each question in the left-hand margin of your answer book.

Read the poem carefully and answer the questions which follow on **Page five**.

A LITTLE MORE

Each minute of a further light
Draws me towards perspective Spring.
I fold the minutes back each night,
 I hear the gossiping

5 Of birds whose instinct carries time,
A watch tucked in the flourished breast.
It ticks the second they must climb
 Into a narrow nest.

So birds. But I am not thus powered.
10 Impulse has gone. My measured cells
Of brain and knowledge are too stored,
 And trust to birds and bells.

Yet longer light is fetching me
To hopes I have no reason for.
15 A further lease of light each day
 Suggests irrational more.

Elizabeth Jennings

Marks

(*a*) At what season of the year and at what time of day is the poem set? **2**

(*b*) What does the image used in line 3 suggest to you about the mood of the poem? Justify your
 answer. **2**

(*c*) Show how the language in stanza 2 creates an impression of the birds and of their behaviour. **4**

(*d*) (i) Comment on the effectiveness of "So birds." (line 9) in relation to the structure of the
 poem. **2**

 (ii) By referring to the word choice used in the rest of stanza 3, show how human behaviour
 contrasts with that of the birds. **4**

(*e*) (i) Comment on the function and position of "Yet" (line 13) in the argument of the poem. **2**

 (ii) Comment on how the language of the last stanza suggests the idea that the speaker is not
 fully in control of her thoughts or feelings. **4**

(*f*) How does the verse form contribute to the impact or mood of the poem?

 You may wish to consider such features as structure, sound, syntax . . . **2**

(*g*) Explain fully the relationship of the title to stanza 1 and to stanza 4. **3**

 (25)

[SECTION B—CLOSE READING OF SPECIFIED TEXTS starts on Page six

SECTION B—CLOSE READING OF SPECIFIED TEXTS

If you have chosen to attempt this Section, you should select only ONE text and answer the questions which follow it.

You should enter the number and the name of the text chosen at the top of the page, and the letter corresponding to each question in the left-hand margin of your answer book.

You are reminded of the instruction on the front cover about the use of texts.

1. *ROMEO AND JULIET*

Read the extract carefully and answer the questions which follow. The number of marks attached to each question will give a clear indication of the length of answer required.

This speech is taken from Act I Scene 1 of the play.

	PRINCE:	Rebellious subjects, enemies to peace,
		Profaners of this neighbour-stainèd steel—
		Will they not hear? What, ho—you men, you beasts,
		That quench the fire of your pernicious rage
5		With purple fountains issuing from your veins!
		On pain of torture, from those bloody hands
		Throw your mistempered weapons to the ground
		And hear the sentence of your movèd prince.
		Three civil brawls, bred of an airy word
10		By thee, old Capulet, and Montague,
		Have thrice disturbed the quiet of our streets
		And made Verona's ancient citizens
		Cast by their grave-beseeming ornaments
		To wield old partisans, in hands as old,
15		Cankered with peace, to part your cankered hate.
		If ever you disturb our streets again,
		Your lives shall pay the forfeit of the peace.
		For this time all the rest depart away.
		You, Capulet, shall go along with me;
20		And, Montague, come you this afternoon,
		To know our farther pleasure in this case,
		To old Free-town, our common judgement-place.
		Once more, on pain of death, all men depart.

Exeunt all but Montague, his wife, and Benvolio

Marks

(*a*) By referring to lines 1 and 2, show how the Prince attempts to capture the attention of the crowd. **2**

(*b*) Why does the Prince pause at the end of line 2? **1**

(*c*) (i) How does the imagery used in lines 3–8 contribute to the Prince's description of himself as "movèd"? (line 8) **3**

 (ii) Comment on the use of the word "mistempered" in line 7. **2**

(*d*) "Three civil brawls . . . cankered hate." (lines 9–15)

 What is the Prince's opinion of the incident which has just taken place?

 Justify your answer by close reference to the text. **3**

(*e*) (i) In the last part of the speech (lines 16–23), how do such features as structure, content, the actor's delivery show the absolute authority of the Prince? **4**

 (ii) There are two other interventions by the Prince in the play.

 Briefly state the circumstances of each. **2**

(*f*) To what extent do you feel that the decisions and behaviour of the older generation determine the fate of the younger generation in the play? **8**

(25)

[Turn over for Text 2—ROBERT BURNS

You are reminded of the instruction on the front cover about the use of texts.

2. ROBERT BURNS

Read carefully the extract from *Tam O'Shanter*, and answer the questions which follow. The number of marks attached to each question will give a clear indication of the length of answer required.

The extract begins at the third stanza.

	O *Tam*! hadst thou but been sae wise,
	As ta'en thy ain wife *Kate's* advice!
	She tauld thee weel thou was a skellum,
	A blethering, blustering, drunken blellum;
5	That frae November till October,
	Ae market-day thou was nae sober;
	That ilka melder, wi' the miller,
	Thou sat as lang as thou had siller;
	That every naig was ca'd a shoe on;
10	The smith and thee gat roaring fou on;
	That at the L—d's house, even on Sunday,
	Thou drank wi' Kirkton Jean till Monday.
	She prophesied that late or soon,
	Thou would be found deep drown'd in Doon;
15	Or catch'd wi' warlocks in the mirk,
	By *Alloway's* auld haunted kirk.
	Ah, gentle dames! it gars me greet,
	To think how mony counsels sweet,
	How mony lengthen'd sage advices,
20	The husband frae the wife despises!
	But to our tale: Ae market-night,
	Tam had got planted unco right;
	Fast by an ingle, bleezing finely,
	Wi' reaming swats, that drank divinely;
25	And at his elbow, Souter *Johnny*,
	His ancient, trusty, drouthy crony;
	Tam lo'ed him like a vera brither;
	They had been fou for weeks thegither.
	The night drave on wi' sangs and clatter;
30	And ay the ale was growing better:
	The landlady and *Tam* grew gracious,
	Wi' favours, secret, sweet, and precious:
	The Souter tauld his queerest stories;
	The landlord's laugh was ready chorus:
35	The storm without might rair and rustle,
	Tam did na mind the storm a whistle.
	Care, mad to see a man sae happy,
	E'en drown'd himsel amang the nappy:
	As bees flee hame wi' lades o' treasure,
40	The minutes wing'd their way wi' pleasure:
	Kings may be blest, but *Tam* was glorious,
	O'er a' the ills o' life victorious!

But pleasures are like poppies spread,
You seize the flower, its bloom is shed;
45 Or like the snow falls in the river,
A moment white—then melts for ever;
Or like the borealis race,
That flit ere you can point their place;
Or like the rainbow's lovely form
50 Evanishing amid the storm.—
Nae man can tether time or tide;
The hour approaches *Tam* maun ride;
That hour, o' night's black arch the key-stane,
That dreary hour he mounts his beast in;
55 And sic a night he taks the road in,
As ne'er poor sinner was abroad in.

Marks

(*a*) Give two important background details which have been established before this extract. **2**

(*b*) (i) Comment on the effectiveness of the language used in lines 3 and 4 in conveying Kate's feelings about Tam. **2**

(ii) Show how the sentence structure of lines 3–12 contributes to their effectiveness in conveying Kate's feelings. **2**

(*c*) Lines 21–36 are highly effective in creating a particular atmosphere. Show how any **two** features such as rhyme, rhythm, sound and pace contribute to this atmosphere. **4**

(*d*) Choose one image from lines 43–50 and show how effective it is in conveying the theme of these lines. **3**

(*e*) Throughout the poem the reader is often aware of the intrusive voice of the narrator. By referring to **two** examples from this extract, show how Burns achieves different effects by means of this device. **4**

(*f*) Women often feature in the poems of Burns, sometimes as inspiration, sometimes as objects of criticism, sometimes as the butt of his humour. Briefly comment on how he presents them in *Tam O'Shanter*, then, more fully, consider his treatment of them in another poem. **8**

(25)

[Turn over for Text 3—*NORTH AND SOUTH*

You are reminded of the instruction on the front cover about the use of texts.

3. *NORTH AND SOUTH*

Read the extract carefully and answer the questions which follow. The number of marks attached to each question will give a clear indication of the length of answer required.

The extract is taken from the early part of the novel.

"I shall not be at home till evening. I am going to Bracy Common, and will ask Farmer Dobson to give me something for dinner. I shall be back to tea at seven."

He did not look at either of them, but Margaret knew what he meant. By seven the announcement must be made to her mother. Mr Hale would have delayed making it till half-past six, but Margaret was of
5 different stuff. She could not bear the impending weight on her mind all the day long: better get the worst over; the day would be too short to comfort her mother. But while she stood by the window, thinking how to begin, and waiting for the servant to have left the room, her mother had gone up-stairs to put on her things to go to the school. She came down ready equipped, in a brisker mood than usual.

"Mother, come round the garden with me this morning; just one turn," said Margaret, putting her arm
10 round Mrs Hale's waist.

They passed through the open window. Mrs Hale spoke — said something — Margaret could not tell what. Her eye caught on a bee entering a deep-belled flower: when that bee flew forth with his spoil she would begin — that should be the sign. Out he came.

"Mamma! Papa is going to leave Helstone!" she blurted forth. "He's going to leave the Church, and
15 live in Milton-Northern." There were the three hard facts hardly spoken.

"What makes you say so?" asked Mrs Hale, in a surprised incredulous voice. "Who has been telling you such nonsense?"

"Papa himself," said Margaret, longing to say something gentle and consoling, but literally not knowing how. They were close to a garden-bench. Mrs Hale sat down and began to cry.

20 "I don't understand you," she said. "Either you have made some great mistake, or I don't quite understand you."

"No, mother, I have made no mistake. Papa has written to the bishop, saying that he has such doubts that he cannot conscientiously remain a priest of the Church of England, and that he must give up Helstone. He has also consulted Mr Bell — Frederick's godfather, you know, mamma; and it is arranged
25 that we go to live in Milton-Northern." Mrs Hale looked up in Margaret's face all the time she was speaking these words: the shadow on her countenance told that she, at least, believed in the truth of what she said.

"I don't think it can be true," said Mrs Hale, at length. "He would surely have told me before it came to this."

30 It came strongly upon Margaret's mind that her mother ought to have been told: that whatever her faults of discontent and repining might have been, it was an error in her father to have left her to learn his change of opinion, and his approaching change of life, from her better-informed child. Margaret sat down by her mother, and took her unresisting head on her breast, bending her own soft cheeks down caressingly to touch her face.

35 "Dear, darling, mamma! we were so afraid of giving you pain. Papa felt so acutely — you know you are not strong, and there must have been such terrible suspense to go through."

"When did he tell you, Margaret?"

"Yesterday, only yesterday," replied Margaret, detecting the jealousy which prompted the inquiry. "Poor papa!" — trying to divert her mother's thoughts into compassionate sympathy for all her father
40 had gone through. Mrs Hale raised her head.

"What does he mean by having doubts?" she asked. "Surely, he does not mean that he thinks differently — that he knows better than the Church."

Margaret shook her head, and the tears came into her eyes, as her mother touched the bare nerve of her own regret.

45 "Can't the bishop set him right?" asked Mrs Hale, half impatiently.

"I'm afraid not," said Margaret. "But I did not ask. I could not bear to hear what he might answer. It is all settled at any rate. He is going to leave Helstone in a fortnight. I am not sure if he did not say he had sent in his deed of resignation."

"In a fortnight!" exclaimed Mrs Hale, "I do think this is very strange—not at all right. I call it very
50 unfeeling," said she, beginning to take relief in tears. "He has doubts, you say, and gives up his living, and all without consulting me. I dare say, if he had told me his doubts at the first I could have nipped them in the bud."

		Marks
(a)	What major event had occurred in Margaret's life on the same day that her father confided in her about his decision to leave the church?	2
(b)	(i) Mrs Hale's mood is described as "brisker" in line 8. Up until this point in the novel what has been Mrs Hale's more usual mood?	1
	(ii) What seems to be the main reason for her feeling this way?	2
(c)	How does the sentence structure of lines 11–13 reflect Margaret's thoughts and feelings at this moment?	4
(d)	"'Mamma! Papa is going to leave Helstone . . . facts hardly spoken." (lines 14–15) By referring closely to the language of these lines, show how the manner in which Margaret broke the news to her mother is conveyed.	2
(e)	Examine Mrs Hale's words from "I don't think . . ." (line 28) to the end of the extract. Trace the development of her reaction to the news.	4
(f)	Show how the image in lines 43–44 reveals Margaret's feelings about her father's behaviour.	2
(g)	In the latter part of the novel Margaret returns to the South and she and Mr Thornton both experience a reversal of fortune. Explain what happens to each and discuss to what extent you find their reconciliation to be convincing.	8
		(25)

[Turn over for Text 4—THE DEVIL'S DISCIPLE

You are reminded of the instruction on the front cover about the use of texts.

4.　*THE DEVIL'S DISCIPLE*

Read the extract carefully and answer the questions which follow. The number of marks attached to each question will give a clear indication of the length of answer required.

Reverend Anderson returns from a visit to Richard Dudgeon's house.

	JUDITH:	[*almost in tears, as if the visit were a personal humiliation to her*] But why did you go there?
	ANDERSON:	[*gravely*] Well, it is all the talk that Major Swindon is going to do what he did in Springtown—make an example of some notorious rebel, as he calls us. He pounced on Peter Dudgeon as the worst character there; and it is the general belief that he will pounce on Richard as the worst here.
5		
	JUDITH:	But Richard said—
	ANDERSON:	[*goodhumoredly cutting her short*] Pooh! Richard said! He said what he thought would frighten you and frighten me, my dear. He said what perhaps (God forgive him!) he would like to believe. It's a terrible thing to think of what death must mean for a man like that. I felt that I must warn him. I left a message for him.
10		
	JUDITH:	[*querulously*] What message?
	ANDERSON:	Only that I should be glad to see him for a moment on a matter of importance to himself, and that if he would look in here when he was passing he would be welcome.
15	JUDITH:	[*aghast*] You asked that man to come here!
	ANDERSON:	I did.
	JUDITH:	[*sinking on the seat and clasping her hands*] I hope he wont come! Oh, I pray that he may not come!
	ANDERSON:	Why? Dont you want him to be warned?
20	JUDITH:	He must know his danger. Oh, Tony, is it wrong to hate a blasphemer and a villain? I do hate him. I cant get him out of my mind: I know he will bring harm with him. He insulted you: he insulted me: he insulted his mother.
	ANDERSON:	[*quaintly*] Well, dear, lets forgive him; and then it wont matter.
	JUDITH:	Oh, I know it's wrong to hate anybody; but—
25	ANDERSON:	[*going over to her with humorous tenderness*] Come, dear, youre not so wicked as you think. The worst sin towards our fellow creatures is not to hate them, but to be indifferent to them; thats the essence of inhumanity. After all, my dear, if you watch people carefully, youll be surprised to find how like hate is to love. [*She starts, strangely touched—even appalled. He is amused at her.*] Yes: I'm quite in earnest. Think of how some of our married friends worry one another, tax one another, are jealous of one another, cant bear to let one another out of sight for a day, are more like jailers and slave-owners than lovers. Think of those very same people with their enemies, scrupulous, lofty, self-respecting, determined to be independent of one another, careful of how they speak of one another—pooh! havnt you often thought that if they only knew it, they were better friends to their enemies than to their own husbands and wives? Come: depend on it, my dear, you are really fonder of Richard than you are of me, if you only knew it. Eh?
30		
35		
	JUDITH:	Oh, dont say that: dont say that, Tony, even in jest. You dont know what a horrible feeling it gives me.
40	ANDERSON:	[*laughing*] Well, well: never mind, pet. He's a bad man; and you hate him as he deserves. And youre going to make the tea, arnt you?

Marks

(a) Explain why Judith is "*almost in tears*" (line 1). 2

(b) By referring to lines 8–11, explain what is revealed about Anderson's attitude to Richard. 2

(c) By examining the language of Judith's speeches (lines 15 to 24), show how she attempts to
 persuade Anderson to her way of thinking. 4

(d) Identify and explain **two** examples of Shaw's use of dramatic irony in Anderson's speech (lines
 25–37). 4

(e) (i) What, in your opinion, is the tone of Anderson's speech (lines 40–41)? Support your
 opinion by textual reference. 2

 (ii) By referring to elsewhere in the extract, show whether this tone towards his wife is
 consistent. 3

(f) ". . . they were better friends to their enemies . . ." (line 35)

 The play features a number of improbable alliances and unlikely friendships. Discuss **two**
 relationships which contribute to your appreciation of the play. 8

 (25)

[Turn over for Text 5—*THE INHERITORS*

You are reminded of the instruction on the front cover about the use of texts.

5. *THE INHERITORS*

Read the extract carefully and answer the questions which follow. The number of marks attached to each question will give a clear indication of the length of answer required.

In this extract the old woman is trying to get "the people" to come to terms with recent events in their lives.

The old woman turned from the fire and spoke to them:

"Now there is Lok."

He looked at her blankly. Fa bent her head. The old woman came to him, took him firmly by the hand and led him to one side. Here was the Mal place. She made Lok sit down, his back against the rock, his

5 hams in the smooth earthen dip that Mal had worn. The strangeness of this overcame Lok. He looked sideways at the water, then back at the people and laughed. There were eyes everywhere, and they waited for him. He was at the head of the procession not at the back of it, and every picture went right out of his head. The blood made his face hot and he pressed his hands over his eyes. He looked through his fingers at the women, at Liku, then down at the mound where the body of Mal was buried.

10 He wished urgently to talk to Mal, to wait quietly before him to be told what to do. But no voice came from the mound and no picture. He grasped at the first picture that came into his head.

"I dreamed. The other was chasing me. Then we were together."

Nil lifted the new one to her breast.

"I dreamed. Ha lay with me and with Fa. Lok lay with Fa and with me."

15 She began to whimper. The old woman made a gesture that startled and silenced her.

"A man for pictures. A woman for Oa. Ha and Mal have gone. Now there is Lok."

Lok's voice came out small, like Liku's.

"To-day we shall hunt for food."

The old woman waited pitilessly. There was still food piled in the recess, though little enough was left.

20 What people would hunt for food when they were not hungry and there was food left to eat? Fa squatted forward. While she was speaking some of the confusion died away in Lok's head. He did not listen to Fa.

"I have a picture. The other is hunting for food and the people are hunting . . ."

She looked the old woman daringly in the eye.

25 "Then the people are hungry."

Nil rubbed her back against the rock.

"That is a bad picture."

The old woman shouted over them.

"Now there is Lok!"

30 Lok remembered. He took his hands from his face.

"I have seen the other. He is on the island. He jumps from rock to rock. He climbs in the trees. He is dark. He changes shape like a bear in a cave."

The people looked outward to the island. It was full of sunlight and a mist of green leaves. Lok called them back.

35 "And I followed his scent. He was there ". . . and he pointed to the roof of the overhang so that they all looked up . . ." he stayed and watched us. He is like a cat and he is not like a cat. He is also like, like . . ."

40 The pictures went out of his head for a while. He scratched himself under the mouth. There were so many things to be said. He wished he could ask Mal what it was that joined a picture to a picture so that the last of many came out of the first.

"Perhaps Ha is not in the river. Perhaps he is on the island with the other. Ha was a mighty jumper."

The people looked along the terrace to the place where the detached rocks of the island swept in towards the bank. Nil pulled the new one from her breast and let him crawl on the earth. The water fell from her eyes.

45 "That is a good picture."

"I will speak with the other. How can he always be on the island? I will hunt for a new scent." Fa was tapping her palm against her mouth.

"Perhaps he came out of the island. Like out of a woman. Or out of the fall."

"I do not see this picture."

50 Now Lok found how easy it was to speak the words to others who would heed them. There need not even be a picture with the words.

"Fa will look for a scent and Nil and Liku and the new one"

The old woman would not interrupt him. She seized a great bough instead and hurled it into the fire. Lok sprang to his feet with a cry, and then was silent. The old woman spoke for him.

55 "Lok will not want Liku to go. There is no man. Let Fa and Lok go. This is what Lok says."

He looked at her in bewilderment and her eyes told him nothing. He began to shake his head.

"Yes," he said, "Yes."

Marks

(a) "Now there is Lok." (line 2)

Explain the significance of the old woman's statement and what has brought this situation about. **3**

(b) By close reference to lines 3–11, show how the writer suggests that Lok may not be suitable for his new role. **4**

(c) "A man for pictures. A woman for Oa." (line 16)

Explain how Lok's people use "pictures". Comment on **two** examples from this extract. **4**

(d) (i) By referring to **one** example of the old woman's words in this extract, explain her significance in the lives of "the people". **2**

(ii) By referring to other parts of the novel, explain how her significance is confirmed. **4**

(e) "She looked the old woman daringly in the eye." (line 24)

By referring to incidents which happen after this extract, show how Fa's behaviour here is an important signal in the development of her relationship with Lok. **8**

(25)

[Turn over for Text 6—IAIN CRICHTON SMITH

You are reminded of the instruction on the front cover about the use of texts.

6. IAIN CRICHTON SMITH

Read the poem carefully and answer the questions which follow. The number of marks attached to each question will give a clear indication of the length of answer required.

AT THE HIGHLAND GAMES

Like re-reading a book which has lost its pith.

Watching the piper dandying over a sodden stage
saluting an empty tent.

The empty beer glasses catch the sun
5 sparkle like old brooches against green.

Fur-hatted, with his huge twirling silver stick
the pipe-major has gypsy cheekbones, colour of brick.

Everything drowses. The stewards with aloof eagle stare
sit on collapsing rock, chair on brown chair.

10 Once the pibroch showed the grave 'ground'
of seas without bubbles, where great hulks were drowned,

meat with moustaches. The heroic dead die
over and over the sea to misty Skye.

Past the phantom ivy, bird song, I walk
15 among crew-cuts, cameras, the heather-covered rock,

past my ancestry, peasants, men who bowed
with stony necks to the daughter-stealing lord.

Past my ancestry, the old songs, the pibroch
stirring my consciousness like the breeze a loch.

20 Past my buried heart my friend who complains
of "All the crime, their insane violence."

Stone by stone the castles crumble. The seas
have stored away their great elegies.

"Morag of Dunvegan." Dandy piper
25 with delicate soft paws, knee-bending stepper,

saluting an empty tent. Blue-kilted stewards
strut like strange storks along the sodden sward.

Finished. All of it's finished. The Gaelic
boils in my mouth, the South Sea silver stick

30 twirls, settles. The mannequins are here.
Calum, how you'd talk of their glassy stare,

their loud public voices. Stained pictures
of what was raw, violent, alive and coarse.

I watch their heirs, Caligulas with canes
35 stalk in their rainbow kilts towards the dance.

Marks

(*a*) (i) How does the first line reveal the attitude of the poet to the Highland Games? **2**

 (ii) Show, by close references to lines 2–9, how this attitude develops. **3**

(*b*) Briefly explain one way in which lines 10–13 contrast with lines 1–9. **2**

(*c*) Show how **two** of the following are effective in conveying the poet's further reflections in lines 14–21:

 (i) repetition; (iv) sentence structure;

 (ii) word choice; (v) sound.

 (iii) imagery; **4**

(*d*) (i) What does the second reference to either the piper (line 24) or to the stewards (line 26) contribute to your understanding of the ideas of the poem? **2**

 (ii) By referring to any **two** of the following, show how they contribute to the tone of the conclusion:

 mannequins (line 30);

 Stained pictures (line 32);

 Caligulas with canes (line 34). **4**

(*e*) By close reference to any other poem by Iain Crichton Smith, show how he examines aspects of the past in order to support a view he has of the present. **8**

 (25)

[Turn over for Text 7—*BOLD GIRLS*

You are reminded of the instruction on the front cover about the use of texts.

7. *BOLD GIRLS*

Read the extract carefully and answer the questions which follow. The number of marks attached to each question will give a clear indication of the length of answer required.

The extract is from Scene 2 in the club. Cassie has got up to dance alone.

NORA: Holy Mother of God, what is she doing?

MARIE: I don't know, Nora.

NORA: Oh Marie get up with her!

MARIE: What!

5 NORA: We can't leave her on her own there, performing for the whole town!

Cassie's dancing becomes more extravagant.

NORA: Marie!

MARIE (*getting up*): Oh Nora I don't even like dancing.

Marie crosses over and joins Cassie who beams, applauding her. Marie starts shuffling cautiously from foot
10 *to foot.*

CASSIE: I'm telling you this is a great diet Marie, you really feel the benefit of the gin.

MARIE: Well maybe you should go easy now, Cassie.

CASSIE: Oh I'm a long way from lockjawed.

Nora is beckoning at them frantically.

15 MARIE: Your mummy's asking us to come and sit down.

CASSIE: The song's just started.

Marie glances round nervously.

What? Are they all watching us?

MARIE: They are.

20 CASSIE: Let them.

MARIE (*with a shaky laugh*): Feel a bit like the last meat pie in the shop out here, Cassie.

CASSIE: Well let them stay hungry. They can just look and think what they like.

MARIE: Cassie, what's wrong?

CASSIE: Oh, I'm just bad Marie, didn't you know?

25 MARIE: No. I never knew that.

CASSIE: You remember that wee girl in Turf Lodge, the one Martin couldn't get enough of? She was a decent wee girl. She's bad now. Ask my mummy.

MARIE: Have you had words?

CASSIE: He's out in less than a year, Marie.

30 MARIE: *Martin*!?

CASSIE: Joe.

MARIE: I know. It'll be all right Cassie.

They stop dancing, they look at each other.

It'll be alright, Cassie.

35 CASSIE: I tell you Marie I can't stand the *smell* of him. The greasy, grinning, beer bellied smell of him. And he's winking away about all he's been dreaming of, wriggling his fat fingers over me like I'm a poke of chips—I don't want him in the house in my *bed*, Marie.

MARIE: You'll cope.

CASSIE: Oh I'm just bad. I am.

40 MARIE: Don't. Don't say that about yourself.

CASSIE: I'll go crazy.

MARIE: I won't let you. You won't get a chance Cassie, I'll just be across the road, I won't let you go crazy. You just see what you'll get if you try it.

Slowly Cassie smiles at her.

45 (*Putting a hand on Cassie's arm*) Now will you come and sit down?

The doors at the back bang open.

Hard white light floods everything.

Oh Jesus it's a raid!

All the women freeze, legs apart, arms raised as if they're being searched.

50 *The same hard light stays on them.*

DEIRDRE: Brick in your hand, hard in your hand, hit skin and it'll burst open and bleed, hit bones and they'll break, you can hear them break, hear them snap.

MARIE: Why are you asking my name, you know my name.

DEIRDRE: Smell the petrol, lungs full of the smell of it. Blow it out again and you'll be
55 breathing fire. Throw fire in a bottle and it runs everywhere like it's water.

MARIE: Everyone knows where I live.

DEIRDRE: Get a car, fast car, drive it till its wheels burn, leave it smoking, burning, exploding.

MARIE: Everyone knows all about me, don't they? So what do you want to know? What do you want?

60 DEIRDRE: The whole town's a prison, smash chunks off the walls 'cause we're all in a prison.

Cut the hard white light.

		Marks
(*a*)	What is the basis of Cassie's "great diet" (line 11)?	1
(*b*)	Show how in lines 2–22 the playwright contrasts the characters of Marie and Cassie through their language and actions.	4
(*c*)	By close reference to two language features in lines 35–37, show how Cassie reveals her attitude towards Joe.	4
(*d*)	Look at the section from line 49 to the end of the extract.	
	(i) In this section of the extract the dramatic style of the play has changed. What features contribute to this change of style?	4
	(ii) What do Deirdre's speeches in this section suggest about her personality? (You should refer closely to lines 51–60.)	4
(*e*)	How effective do you find the sudden changes of style in *Bold Girls*? Refer briefly to this extract, and to other relevant occasions in the play.	
	You may wish to refer to how they affect revelation of character, exploration of theme, dramatic impact . . .	8
		(25)

[Turn over for Text 8—*SUNSET SONG*

You are reminded of the instruction on the front cover about the use of texts.

8. *SUNSET SONG*

Read the extract carefully and answer the questions which follow. The number of marks attached to each question will give a clear indication of the length of answer required.

The extract is taken from "Harvest".

But Chris didn't care, sitting there at Blawearie with young Ewan at her breast, her man beside her, Blawearie theirs and the grain a fine price, forbye that the stirks sold well in the marts. Maybe there was war and bloodshed and that was awful, but far off also, you'd hear it like the North Sea cry in a morning, a crying and a thunder that became unending as the weeks went by, part of life's plan,
5 fringing the horizon of your days with its pelt and uproar. So the new year came in and Chris watched young Ewan change and grow there at her breast, he was quick of temper like his father, good like his mother, she told Ewan; and Ewan laughed *God, maybe you're right! You could hardly be wrong in a thing after bringing a bairn like that in the world*. And she laughed at him *But you helped a little!* and he blushed as red as he always did, they seemed daft as ever in their love as the days wore on. It was still as
10 strange and as kind to lie with him, live with him, watch the sweat on his forehead when he came from tramping a day in the parks at the heels of his horses; still miracle to hear beside her his soundless breathing in the dark of the night when their pleasure was past and he slept so soon. But she didn't herself, those nights as the Winter wore to March, into Spring: she'd lie and listen to that hushed breathing of his one side of her, the boy's quicker breath in his cradle out by—content, content, what
15 more could she have or want than the two of them, body and blood and breath? And morning would bring her out of her bed to tend young Ewan and make the breakfast and clean out the byre and the stable, singing; she worked never knowing she tired and Long Rob of the Mill came on her one morning as she cleaned the manure from the stable and he cried *The Spring of life, eh, Chris quean? Sing it and cherish it, 'twill never come again!*

20 Different from the old Rob he looked, she thought, but thought that carelessly, hurried to be in to young Ewan. But she stopped and watched him swing down the rigs to Ewan by the side of his horses, Ewan with his horses halted on the side of the brae and the breath of them rising up like a steam. And she heard Ewan call *Ay, man, Rob*, and Rob call *Ay, man, Ewan*, and they called the truth, they seemed fine men both against the horizon of Spring, their feet deep laired in the wet clay ground, brown and
25 great, with their feet on the earth and the sky that waited behind. And Chris looked at them over-long, they glimmered to her eyes as though they had ceased to be there, mirages of men dreamt by a land grown desolate against its changing sky. And the Chris that had ruled those other two selves of herself, content, unquestioning these many months now, shook her head and called herself daft.

Marks

(a) Comment on the effectiveness of the extended simile, "like the North Sea . . . pelt and uproar" (lines 3–5), to describe Chris's view of the war.

3

(b) (i) What is revealed about the relationship between Chris and Ewan by lines 7–9 ("and Ewan laughed . . . as the days wore on.")?

2

 (ii) By referring to the language of lines 9–17 ("It was still as strange . . . knowing she tired"), show how a convincing picture of Chris's contentment is conveyed.

4

(c) Show how Long Rob's words (lines 18–19) act as a link between the two paragraphs.

2

(d) By commenting on particular words and phrases, show how Chris's mood develops (lines 20–28).

6

(e) To what extent do you find the ending of *Sunset Song* to be pessimistic? In your answer you should refer briefly to the passage and more fully to the remainder of "Harvest" and to the last section of the novel, "The Unfurrowed Field".

8

(25)

[Turn over for Text 9—PHILIP LARKIN

You are reminded of the instruction on the front cover about the use of texts.

9. PHILIP LARKIN

Read the poem carefully and answer the questions which follow. The number of marks attached to each question will give a clear indication of the length of answer required.

REASONS FOR ATTENDANCE

The trumpet's voice, loud and authoritative,
Draws me a moment to the lighted glass
To watch the dancers—all under twenty-five—
Shifting intently, face to flushed face,
5 Solemnly on the beat of happiness.

—Or so I fancy, sensing the smoke and sweat,
The wonderful feel of girls. Why be out here?
But then, why be in there? Sex, yes, but what
Is sex? Surely, to think the lion's share
10 Of happiness is found by couples—sheer

Inaccuracy, as far as I'm concerned.
What calls me is that lifted, rough-tongued bell
(Art, if you like) whose individual sound
Insists I too am individual.
15 It speaks; I hear; others may hear as well,

But not for me, nor I for them; and so
With happiness. Therefore I stay outside,
Believing this; and they maul to and fro,
Believing that; and both are satisfied,
20 If no one has misjudged himself. Or lied.

30 December 1953

Marks

(a) Choose one example of word choice in lines 3–5 and show how it conveys the poet's attitude to "the dancers".

2

(b) (i) "—Or so I fancy . . ." (line 6)

In what way does this opening to verse two signal a change in the poet's attitude?

1

(ii) Show how sentence structure in lines 6–9 reflects his state of mind.

4

(c) "—sheer

Inaccuracy, as far as I'm concerned." (lines 10–11)

Comment on the effectiveness of one poetic technique in these lines in developing the ideas of the poem.

2

(d) By commenting on references to music in the poem, show how the poet illustrates the difference between himself and the dancers.

4

(e) "If no one has misjudged himself. Or lied." (line 20)

Explain the meaning of the last line and comment on its effectiveness as a conclusion to the poem.

4

(f) It has been said that the titles of Larkin's poems are often extremely significant. After briefly giving your views on the contribution of the title to the meaning of this poem, discuss more fully how the title of another of his poems is important to your understanding of that poem.

8

(25)

[Turn over for PART 2—CRITICAL ESSAY

PART 2—CRITICAL ESSAY

Attempt ONE question only, taken from any of the Sections A to D.

In all Sections you may use Scottish texts.

You should spend about 50 minutes on this part of the paper.

Begin your answer on a fresh page.

If you use a Specified Text as the basis for your Critical Essay, you must not rely ONLY on any extract printed in Part 1 in this paper. If you attempt Section C—Poetry, you should note the additional instruction at the head of Section C.

SECTION A—DRAMA

If you have answered on a play in the Specified Text option in Part 1 of the paper, you must not attempt a question from this Drama Section.

In your answer in this Section you should, where relevant, refer to such features as dialogue, characterisation, plot, theme, scene, climax, style, structure . . .

1. By referring closely to one or more than one episode in a Shakespearean play, show how you were made to feel a range of emotions.

2. Many dramatists make use of very restricted settings—for example, a workplace, a house, or even a single room—for most of the play.

 Choose a play whose setting is restricted in this way and examine the use the dramatist makes of the setting to develop features such as character, theme, mood . . .

3. Consider a play in the course of which one of the major characters changes significantly. Outline the nature of the change, and go on to discuss to what extent the dramatist convinces you that the change is credible and consistent with the play's theme.

4. (*a*) Choose a play which you have studied and examine the features it has which would make its performance have an impact on a theatre audience.

 (You might wish to refer to such things as visual impact; effective use of sound; tension; humour; moments of high emotion . . .)

 OR

 (*b*) Name a play you have read and seen in performance and examine the features of the text and the performance which made an impact on you.

 (You might wish to refer to such things as visual impact; effective use of sound; tension; humour; moments of high emotion . . .)

5. Choose a play which you found genuinely funny in places, yet which had also a serious theme. By referring closely to the text, explain the humour and the seriousness that underlies it.

SECTION B—PROSE

> **If you have answered on a prose work in the Specified Text option in Part 1 of the paper, you must not attempt a question from this Prose Section.**
>
> **In your answer in this Section you should, where relevant, refer to such features as setting, theme, characterisation, plot, content, style, structure, language, narrative stance, symbolism . . .**

6. Sometimes the significance of the title of a novel or short story is not immediately obvious.

 Choose a novel or short story which fits this description, and show how, after careful study, the full significance of the title becomes clear.

7. "Non-fiction is seldom objective. Often it sways your feelings or influences your thoughts."

 By referring closely to a work of non-fiction (such as an essay, a piece of journalism, a biography, a travel book . . .), show how the writer does more than simply convey information.

8. Choose a novel or short story whose structure is based on a journey or a quest. Show how the writer makes use of this structure to develop character and theme.

 (The journey or quest could be literal or metaphorical.)

9. What was your reaction to the ending of a novel you have read? By referring closely to the ending and to its relationship with the whole text, explain why you felt as you did.

SECTION C—POETRY

> **If you have answered on a poem in the Specified Text option in Part 1 of the paper, you must not attempt a question from this Poetry Section. You may not base an answer on Burns's "Tam O' Shanter", Crichton Smith's "At the Highland Games" or Larkin's "Reasons for Attendance".**
>
> **In your answer in this Section you should, where relevant, refer to such features as rhyme, rhythm, word choice, language, sound, imagery, symbolism, style, structure . . .**

10. Many poems are concerned with a sense of loss or deep sadness at a particular event.

 Examine the means by which a poet, in one poem, conveys either of these emotions to you.

11. Is there a poem which has genuinely shocked or inspired you?

 Explain what aspects of the poem's language and ideas produced this response.

12. Choose a poem which appeals to you because certain words, or lines, or even the whole poem, can be interpreted in more than one way.

 By referring closely to the text, discuss these ambiguities and show to what extent they contribute to your appreciation of the poem as a whole.

13. Sometimes a reader can admire the techniques of a particular poem yet disagree or lack sympathy with some of the ideas it conveys.

 Select a poem which fits this description and, by close reference to the text, justify your view of the techniques and the ideas.

[Turn over for SECTION D—MASS MEDIA

SECTION D—MASS MEDIA

> **If your Review of Personal Reading is based entirely on a radio, television or film script, you must not attempt a question from this Mass Media Section.**

14. By referring closely to one film, select and analyse a sequence which you feel is technically effective, explaining how it contributes to your understanding of the film's deeper theme(s). (You may wish to refer in your answer to mise-en-scène, montage and soundtrack.)

15. By referring closely to a film you have studied, show to what extent its artistic merit has been affected by commercial considerations.

16. Sometimes our personal views of an individual are influenced by the representations constructed by the media. By referring closely to artefacts from more than one medium, show how these representations have influenced your views of one such individual.

17. "We're trapped—somewhere between Brigadoon and Braveheart."
 Are you satisfied with representations of Scotland and the Scots in one particular medium? (You should refer closely to your chosen text(s) in your answer.)

18. By referring closely to one, or more than one television drama you have studied, show how a particular ideology shaped aspects of the text(s).

19. To what extent does the success of a television drama (such as a soap opera, a series, a serial . . .) depend on its representations of contrasting groups—young and old, rich and poor, locals and outsiders . . .?

[END OF QUESTION PAPER]

[BLANK PAGE]

[BLANK PAGE]

0860/201

SCOTTISH
CERTIFICATE OF
EDUCATION
1999

TUESDAY, 4 MAY
9.15 AM – 11.20 AM

ENGLISH
HIGHER GRADE
Paper I

There are **two parts** to this paper, Part 1 (Interpretation) and Part 2 (Report). You should attempt both parts.

Part 1 (Interpretation), on pages 2, 3 and 4, is worth 40 marks. There are two passages, with questions following. Use the left-hand margin of the answer book to indicate clearly the questions attempted.

Part 2 (Report), on pages 6, 7 and 8, is worth 35 marks. You should begin your Report on a fresh page of the answer book.

PART 1—INTERPRETATION

Attempt all of Part 1. You should spend approximately 1 hour 5 minutes on this part of the paper, including reading time. There are TWO passages and questions.

Read both passages carefully and then answer all the questions which follow on page four. **Use your own words whenever possible and particularly when you are instructed to do so.** The number of marks attached to each question will give some indication of the kind of answer required.

It is important that you read both passages before you attempt to answer any of the questions.

The two passages have been taken from a book of essays on the subject of screen violence. The first, by Nicci Gerrard, presents her views as a journalist and mother; the second, by Michael Medved, a film critic for the "New York Post", attacks Hollywood as the main cause of the "problem".

PASSAGE 1

Sometimes, at night, when I leave my children in their beds, and they lie there after their stories and quarrels, after their teeth have been cleaned, after I've sung half-remembered lullabies to them in my
5 tuneless voice and hugged them and put their squashed and balding teddies under the crook of their arm and turned out the lights—sometimes, then, they shut their eyes against the orange street lamp just outside their window and play a game.
10 It's called, simply, "films" or sometimes "videos". They give each other titles (*The Wizard of Oz, Dumbo . . .*) and they run the films through in their head, their closed lids the private screens on which are projected oft-watched and well-remembered
15 scenes. They switch films every so often and later they discuss them with each other like regular filmgoers.

Sometimes, later in the evening, one of them will appear downstairs, a pyjamaed stocky ghost
20 lurking on the fringes of our adult evening (scenes from *ER* or from war-zones are hastily turned off the TV), and say that they are scared. Scared of monsters, scared of wars, scared of you going away, scared of thunder, scared of a rustle outside the
25 bedroom door, scared of don't know what, just scared. And if we say, but there's nothing to worry about, you're safe, there's nothing there, then they reply that they know that: *it's inside their heads and they can't make it go away.* It's as if the images that
30 flicker against their eyelids night after night are locked into their skulls when they sleep, and go on burning there.

It's not just real violence which unreels itself in the imagination, fast-forward, fast-backwards and
35 pause. I have sat in a cinema and watched with peeled-back sight and a whimpering heart, peering aghast at the claustrophobic corners of the screen. I like *Bringing Up Baby* and Jane Austen adaptations. I get very scared by images of
40 violence. I get very worried by images of violence towards women. I get weepy and terrified by images of violence towards children.

Many people—more of them all the time—believe that there is a direct relationship between the
culture we consume and the people we become. 45 See violence, be violent. Conversely, I suppose (though this is not often spelt out): see happiness and be happier, see goodness and be good, see innocence and become more innocent.

In truth, though, violence is an image bred in the 50 bone for the way we live as we approach the end of the millennium; it feeds off the lurching fears we have about our society. But, we've always had violence in our culture, in the sublimest art as well as in the tackiest. The crucifix is an icon of agony 55 and torture; Shakespeare gives us massacres, extreme torture, even cannibalism. Film, though, seems more visceral as a form than written or performed texts. Filmmakers seem constantly to push back the barriers of what is acceptable. 60

"I don't see why they feel the need to be so violent": the bewildered or aggrieved refrain of so many filmgoers. But they do feel the *need*. Who can dictate what sets the creative juices flowing? Today, in the hectic uncertainties of a millennium 65 ending, many filmmakers express themselves through violence. That's their voice, their context; that's the woeful and jagged darkness where they feel at home. You can't exile them to gentleness or optimism. Some of the most powerful cultural 70 works of the last decade have been couched in the language of disturbance and pain.

Yet when I go to look at my children as they lie sleeping, cast by slumber into a resemblance to each other that they never possess when awake, 75 arms flung above their heads, mouths slightly open, a puff of breath fluttering on their upper lip, and I see by their rapid eye movement that they must be dreaming—then I confess that I want them to dream about peaceful, comforting things. 80 Not cartoon wars and car chases and shiny robots with shiny guns, but horses in fields and dogs in baskets and blue skies and all the saccharine and childish things that only unimaginative adults ever think belong to the fierce and dark imagination of a 85 child.

(Nicci Gerrard)

PASSAGE 2

In this essay, the film critic, Michael Medved attacks the Hollywood entertainment industry.

The question of media influence is properly understood as an environmental issue. At a time when we are demanding that industry takes more responsibility for its pollution of our air and
5 our water, it's entirely appropriate to insist that Hollywood and its like demonstrate greater accountability for their pollution of the cultural atmosphere we all breathe.

Understanding the four lies that Hollywood
10 inevitably mobilises on its own behalf is essential for a balanced discussion of the current state of the entertainment industry. It's also appropriate to begin answering those lies with the truth—knowing the truth, speaking and writing the truth and, as far
15 as possible, living the truth.

This means that the first lie—arguing that violent entertainment actually influences no one— deserves an affirmation of the simple but profound idea that "messages matter". The notion that
20 "messages matter" doesn't mean that exposure to one vile and violent movie, or one example of trash TV, will instantly change your life or reshape your personality—any more than a single indulgence in a hot fudge sundae will alter your cholesterol level.
25 Repeated consumption of ice cream delights will, however, exert a cumulative impact on your health (and your waist line) and by the same token consistent indulgence in the worst aspects of the popular culture will exert a slow, subtle influence
30 on your home and your family.

As to the second lie—the suggestion that popular culture merely reflects reality and does not shape it—it's essential to educate ourselves and our children to understand media distortions and to
35 rely less on this source of information in drawing conclusions about the world around us. This education should take place not only at home but in our schools. Among children, the tendency to accept unthinkingly Hollywood's often brutal
40 vision of society greatly encourages the sour, apathetic, cynical and self-pitying mood that afflicts too many young people in western society. We should lose no opportunity to affirm that the world is a far more hopeful place than might be
45 inferred from the dark fantasies of the American entertainment industry.

The third lie—that Hollywood merely gives the public what it wants—highlights the enormous difficulties in pushing the entertainment establishment to adopt a more responsible attitude 50 towards media violence. As any study of box-office performance shows, the public has already displayed a clear preference for less brutal, more family-orientated fare. The industry's reluctance to respond suggests that changing the 55 viewing patterns of the public isn't enough to alter the emphasis of the Hollywood elite. A comprehensive approach to the problem involves a more sceptical view from critics and Hollywood insiders of the latest examples of "artistic" gore 60 from filmmakers such as Scorsese or Tarantino, and a less dismissive attitude towards the finest achievements in family friendly entertainment. This means that Hollywood needs an attitude adjustment not only towards what constitutes 65 good business, but also towards what amounts to worthy art.

Finally, the fourth lie—that we can simply switch off the telly or not go to the cinema or video shop—presents the most personal challenge. 70 No, it's not possible simply to "turn off" the popular culture in our lives, as promoted in songs, magazines, chat shows, TV commercials, billboards, newspapers . . . But it is possible to turn it down. The messages of the entertainment industry may 75 be inescapable, but it's still within our grasp to reduce the amount of time we waste on show business fantasies. In Great Britain, the average citizen spends an average of twenty hours a week watching the small screen. At the conclusion of an 80 average life span, this represents a total of nine uninterrupted years glued to the television set. The most significant problem in the popular culture isn't too much violence; it's too much TV and video, period. 85

In devising strategies for dealing with screen violence the most important priority is to encourage personal action to reduce media consumption. On this basis, we can each move swiftly and decisively to make a difference, taking 90 powerful, private steps to share our own more responsible media environments.

(Michael Medved)

QUESTIONS FOR PART 1—INTERPRETATION

Questions on Passage 1

Marks

(*a*) By referring to lines 1–9 ("Sometimes . . . play a game."), explain what kind of mother the writer seems to be.

2

(*b*) Identify the mood of lines 18–32. By referring to both imagery and sentence structure, show how the writer creates this mood.

4

(*c*) Account for the writer's use of italics in:

 (i) lines 11–12;

 (ii) lines 28–29.

2

(*d*) Show how the writer's language in lines 33–42 demonstrates her strength of feeling about films containing violent scenes.

In your answer, you may refer to word choice, sentence structure, imagery, repetition, or any other language feature.

4

(*e*) Explain fully how the context of lines 43–49 helps you to arrive at the meaning of "Conversely" (line 46).

2

(*f*) Explain in your own words what the writer means by **one** of the following phrases:

 (i) "an image bred in the bone" (lines 50–51);

 (ii) "feeds off the lurching fears" (line 52);

 (iii) "more visceral as a form" (line 58).

2

(*g*) According to the writer, some filmmakers feel the need to express themselves through violence.

In your own words, give **two** reasons for this.

You should refer to lines 61–72 in your answer.

2

(*h*) (i) "Yet when I go . . . about peaceful, comforting things." (lines 73–80)

 Show how the structure of this sentence helps to reflect the writer's line of thought.

2

 (ii) To what extent do you find lines 81–86 effective as a conclusion to the line of thought? You should refer closely to the sentence in your answer.

4

(24)

Questions on Passage 2

(*i*) By referring to the opening paragraph (lines 1–8), explain what the writer means by his statement that media influence is "an environmental issue" (line 2).

2

(*j*) Look carefully at paragraphs 3–6 (lines 16–85).

 (i) What are the "four lies" (line 9) which the writer believes Hollywood uses to justify screen violence?

2

 (ii) Consider the three "lies" described in lines 31–85. Explain **in each case** what the writer suggests should be done to improve the situation created by the lie.

 (You should use your own words as far as possible.)

6

(*k*) By referring to two examples from lines 86–92, show how the writer uses word choice to emphasise the importance of the individual.

2

(12)

Question on Both Passages

(*l*) Which of the two passages do you find more stimulating?

Justify your view by referring closely to the style and/or ideas of **both** passages.

4

(4)

Total (40)

[Part 2 (Report) is on Pages 6, 7 and 8]

[Turn over for Part 2 (Report)]

PART 2—REPORT

READ THE INSTRUCTIONS BEFORE YOU ATTEMPT THIS QUESTION

(i)

No Quick Fix

Should charities have to raise money to obtain urgently needed items like body scanners or to keep a children's ward open? Surveys have shown that most people think that governments, not charities, should take responsibility for the community's basic needs.

Many social services in Britain are heavily dependent on charitable support. Hospital fund-drives are commonplace. Top charities concerned with health receive more donations than any other cause, closely followed by welfare issues such as care for the young and elderly.

This is a growing trend. Recent changes in the way local government is run aim to give voluntary organisations a far greater role as providers of local welfare services.

Charities are wary that their work can provide a "quick fix" to problems which they believe are the government's responsibility to solve. Barbara Vellacott, speaking for four of the largest UK charities, stated: "Our main concern is that the next generation grows up aware of and sensitive to the causes of poverty and injustice in the world, and committed to addressing these at their roots."

(ii)

Lottery Recently Accused Over Drop in Charity Donations

Charities have accused the National Lottery of contributing to a continuing fall in donations which amounted to a loss of £650m throughout Britain last year and have seen a significant drop in the proportion of Scots who give to charity this decade.

The National Council for Voluntary Organisations (NCVO) released findings yesterday which showed donations to charities throughout Britain fell by 12% in the last two years— £4580m compared to £5230m.

The percentage of people regularly giving to charity has fallen from a pre-lottery level of 81% in 1993 to 68% last year. The figures also showed that the percentage of people who thought the National Lottery was a good way of helping charities fell from 66% in 1995 to 48% last December.

A spokesman from the NCVO said: "Smaller charities have lost out most of all. We can't prove a link between the lottery and the fall in donations but we can't think what other reason there can be."

A spokesman from Camelot (the National Lottery operator) stated: "We have given more than £2 billion to good causes since the lottery began. The criticism that it has a detrimental effect on charity giving is ludicrous."

(iii)

"No thanks. I already give to the lottery."

READ THIS SECTION BEFORE YOU ATTEMPT THE QUESTION

CHARITY

The items on pages 6, 7 and 8 relate to the topic of charity in Britain. Read them carefully.

You should spend approximately one hour on this part of the paper, which is worth 35 marks.

Your task is to write a report on this topic. You should select the relevant information and reorganise the material in a way that shows an understanding of the main issues. You might find it helpful to consider the following:

(a) the growth of charities in Britain;

(b) differing attitudes towards the roles of charitable organisations and of the government;

(c) recent developments.

You must base your report entirely on the material presented to you, and on any direct inferences you can draw from it. You should use your own words as far as possible. You should take an objective point of view. Write your report in formal, continuous prose. You are likely to be able to complete this task in about 450 words, but there is no penalty for exceeding that length.

(iv)

GIVERS WHO DEPEND ON GIVING

Today, charity is big business. The old fashioned image of well-to-do ladies performing good deeds among the poor bears little resemblance to the highly professional activities of giant charities such as Oxfam or Save the Children.

There are over 170,000 charity organisations registered with the Charity Commission, which was set up in 1853 to oversee how Britain's charities are run. They have an annual turnover of over £18 billion. These organisations range from huge modern institutions raising tens of millions for overseas aid or cancer research to many tiny charities run in village halls.

To qualify for charitable status, an organisation must exist for one of a number of reasons laid down in law. These include relieving poverty, advancing education or religion, or other activities deemed beneficial to the community, such as protecting animals, helping ex-prisoners to settle or preserving the environment.

Charities raise money in many different ways. Side by side with the traditional ones—such as door-to-door appeals, street collections and jumble sales—increasingly complex fund-raising methods have emerged recently. Most of the large charities "direct-mail" their leaflets to homes and in this way target potential donors. With the current drop in levels of individual donations, charities are encouraging planned giving—a medium to long term commitment by donors to a particular cause.

(v)

A HISTORY OF CHARITY

In the 19th century in Britain, hospitals and schools for the poor existed thanks only to charitable organisations. Charitable bodies were set up in the 1860s to improve the housing of poor families.

But social historians have pointed to the mixed motives that the wealthier classes had for carrying out charitable work. For rich people, doing "good works" was considered to be visible proof of their Christian morals. Philanthropists were often motivated by the fear that, unless something was done to improve the living conditions of the poor, there would be terrible social disorder.

Although governments have played a role in the past in providing public social services, it was not until the emergence of modern industrial societies this century that the state began to take on the responsibility for people's welfare needs. In Britain, the "welfare state" did not really develop until after the Second World War (1939–45).

(vi)

Please let's have a Red Faces Day instead

I am writing to thank you lovely people who organised Red Nose Day today, and all the Golden Hearts, telethons and so on; Daddy tells me that you give your time for nothing and that you're all terribly famous. But something's bothering me. I don't want to sound ungrateful for everything you do on our behalf; it's just that sometimes I wonder if you are directing all your energy at the wrong target. I'm one of the kids you did it for. In my case it's spina bifida.

While greatly appreciating all the charitable work done on our behalf, I would like to point out that in the real world, at the sharp end, services have been drastically reduced. Yet celebrities and charitable organisations often try to help by offering trips to Disney World which doesn't really go far to solving the real problems of those in need.

And that brings me back to Red Nose Day. I'm a bit worried that it makes matters worse; the better you do, the less pressure there is on government to do their bit. Do you see what I mean? You're hiding the blood in the gutter, you're muffling the cries in the night that might just penetrate ministerial conscience; by your brilliant generosity, you are reaching the parts that government funding ought to reach.

(vii)

Some brief views about giving to charity:

"I believe there is another route out of the plethora of social problems we face. What we need is more self sustaining social businesses that create work and support, and are not reliant on public generosity."

John Bird, Editor of *The Big Issue* (magazine sold in aid of the homeless)

"It's the working class and the kids that are the most generous. Sometimes a crowd look really rowdy—as though they're up to no good. Then they surprise you by emptying out their pockets."

Cheryl, 23 year old, living rough in London

"I give £100 a week to charity. I don't believe in state aid: it ought to be voluntary—I give out of a sense of obligation to others, a sense of duty to help the less-fortunate."

Murray, solicitor earning £45,000 a year

"Once again another huge winner on the National Lottery. Whenever these big winners are asked: 'How will you spend your millions?' the usual reply is a new house, new car, a holiday ... I have not yet heard of one of these new millionaires say they are intending to donate a decent sum to one of the very needy charities. If I won, certain charities would be my first priority spend."

Helen, housewife

[END OF QUESTION PAPER]

0860/202

SCOTTISH
CERTIFICATE OF
EDUCATION
1999

TUESDAY, 4 MAY
1.30 PM – 3.05 PM

ENGLISH
HIGHER GRADE
Paper II

There are **two parts** to this paper and you should attempt both parts.

In Part 1, you should attempt **either** Section A (Practical Criticism) **or** Section B (Close Reading of Specified Texts).

In Section A there are two optional questions for Practical Criticism. If you choose Section A, attempt only one of the two Practical Criticism questions.

In Section B there are nine optional questions on Specified Texts. If you choose Section B, attempt only one of the nine Specified Texts questions.

Each option in Part 1 is worth 25 marks.

In Part 2 (Critical Essay), you should attempt **one** question only, taken from any of the Sections A–D.

Your answer to Part 2 should begin on a fresh page.

Each question in Part 2 is worth 30 marks.

NB You must not use, in any part of this paper, the same text(s) as you have used in your Review of Personal Reading.

You must also pay attention to the instruction at the top of each Section in Part 2 about the use of genres and specified texts.

Index of Specified Texts/Authors in Part 1 Section B

SCOTTISH
QUALIFICATIONS
AUTHORITY

PART 1

You should spend approximately 45 minutes on this part of the paper.

SECTION A—PRACTICAL CRITICISM

If you choose this Section, attempt <u>either</u> Option 1 below <u>or</u> Option 2, which begins on Page four.

Option 1

Enter the letter corresponding to each question in the left-hand margin of your answer book.

Read the extract carefully and answer the questions which follow **on Page three**.

A stranger is asking a shepherd for permission to visit a part of the farm marked on his map.

Weel, I digs oot ma specs and haes a geid lang ganner and damn me gin he's no pointin at ocht but a wee scrubby clump o blackthorn and gorse that caps a neb o the Screel Hill. "Fair enough," says I, "but ye'll nivver git yer car up yonner. Ye'll hae tae tramp it."

"Nae problem," says he, "Fir I've brocht ma bits," and he lowps oot the car and swaps his shin and
5 plods aff up the brae, and faith, it wis five tae six ooers afore he ever cam back doon.

Masel, I nivver thocht mair aboot it, till I wis sittin intae ma denner, and the wife ups and wants tae ken whase car it hid bin. "Some gyte-like crater," I tells her, "that wantit tae watch some auld trees."

"Whit on irth fir?" she spiers.

"Dinnae ask me!" I cries, "Fir I'm damnt if I ken, but I reckon he's a sicht saft aboot the heid." Aifter
10 a', whae in his richt senses wid be tacklin a five-mile hike jeest tae peer at an auld ill-riggit plantin that's no even ony yeese fir kinnlin? Fir that's a' it wis—a stragglin bit wilderness o thorn and tangel, clingin tae a bare wind-sweepit hillside. I'm no even shair whit it wis daein there, fir naebody ever bothert tae tend nor fell it.

Mind ye, it wis a rarely bonnie wee spot, and ma hirsel went richt bye the back o it. Maist days I'd drap
15 aff yonner fir ma piece. There wis an auld broken-doon dry-stane dyke whaur I'd coorie in tae dodge yon bitin winter winds that howlt sae snell ower thae hill-faces. But in the springtime it wis fair a bleeze o colour, whit wi the white o the thorn-blossom, and the bricht gowden yoitlich o the whins. And when yer autumn fruits were oot, ba crivvens, it wid be fair hoachin wi shilfies and siskins and the like, fir it wis ayeways laden doon wi hips and haws, and brummles and berries. I yeest tae sit there flingin jaaps o
20 breid tae the speugs, while ma dugs snuggelt in aside me, their heids on their paws, and yin ee ayeways open and watchin the wee burdies. And whiles in late summer I'd lie back and doze in the sunlicht, lissnin tae the poppin o the ripe whin-pods, and watchin the willae-herb waftin bye. Aye, it wis ayeways fine and peacefou up yonner, and it wis aye a damnable effort tae rise up and gan trampin roond anither fower-ooers-worth o windrusselt hill-country.

25 It wis aye a favourite spot o mine, and mainly on accoont o the view. Fir ye could see richt oot across the Rough Firth tae the licht-hoose o Satterness. And ye could watch oot ower the sands o the Solway tae the wee pit-toons o Cummerlan, and ayont them tae the bens o the Lake Dis'rict itsel! Sometimes at the lambin I've bin up yonner at nicht, and ye could see a' the lichts o Maryport glintin and glimmerin oot ontae the watter. Mony's the time I've sut up yonner and watcht the collier-boats come churnin
30 across fae Worki'ton or Maryport. They'd rin richt in wi the tide, and beach theirsels up ontae the sands o Rascarrel Bay. Then, when the tide wis lappit oot, they'd be left high and dry, and the big Clydesdales wid drag the fairmcairts doon tae be loadit wi coal. And syne a' th'empty boats wid lie like strandit whales till the nixt tide cam and floatit them aff. And then they'd awey hame tae Inglan.

Onyroad, I pit the haill bisniss o the plantin fae ma mind, and got on wi the darg o the fairm.

The Flood Bush, Bill Copland

Marks

(a) How are the enthusiasm and energy of the stranger suggested by his words and actions in
 lines 4–5? **2**

(b) Show how the shepherd exaggerates the stupidity of the stranger. In your answer you should
 refer to lines 7–9. **2**

(c) How does the word choice or imagery in lines 9–13 effectively convey a picture of the harshness
 of the landscape? **2**

(d) Explain the function of the phrase "Mind ye" (line 14) in the structure of the passage. **2**

(e) In lines 14–24 the shepherd mentions two functions which the wood fulfils for him: as a refuge
 and as a source of pleasure.
 Show how the word choice, sound and imagery make the contrast between the two functions
 clear. **6**

(f) (i) Show how the sentence "It wis aye a favourite . . . o the view." (line 25) helps to create a
 shift in perspective at this point in the passage. **2**

 (ii) How does the use of place names in lines 25–31 help to develop this change in perspective? **1**

(g) How well does the sentence structure of lines 31–33 reflect the activities of the collier-boats? **2**

(h) To what extent are contrasting aspects of the shepherd's personality revealed in the extract?
 Refer to the whole passage in your answer. **6**

 (25)

[SECTION A—Option 2 starts on Page four

SECTION A—PRACTICAL CRITICISM (continued)

Option 2

Enter the letter corresponding to each question in the left-hand margin of your answer book.

Read the extract carefully and answer the questions which follow on **Page five**.

William Golding is describing dawn seen from a boat on the River Nile.

I surfaced—probably from sleep though I couldn't be sure at the time—at about a quarter to six. It was still dark outside and cold. I looked out. Strange! There were robed people about, some in boats, some on the bank but no one was moving. The water was so flat that the current was not visible. The stillness of the scene was such that the figures of robed men seemed to brood as if contemplating some
5 inevitable and awful tragedy before which movement and noise were useless and irrelevant. Had they, I asked myself, sat, crouched, leaned or stood thus all night? Were they—were *we* since the night had left me diminished—like lizards, which require the sun's warmth before their muscles can operate? I watched them as the dawn lightened swiftly and the faintest trace of mist drew away from the water. A fisherman was crouched in his rowing boat, his ridiculous oars (two unshaped baulks of timber) lying
10 idle along the thwarts, his head closely wrapped against the chill of dawn. He was moored only ten yards from us. He never moved, wrapped elaborately in a thick galabia. It was as if the night was a time for grief from which men had to recover daily.

The east lightened all at once. A woman crept out of a house with a tin water vessel on her head. She came slowly down the mud bank and the tin flashed as the first grain of the sun struck it. The
15 fisherman lifted his head. Figures began to move on the bank. It was theatrical in that it led from the first tableau of grief to the common preoccupations of day in two minutes flat. A woman led a donkey. The fisherman shipped his ridiculous oars and rowed slow strokes. Two men spread their robes and squatted by the water. The rising sun grabbed the hill of straw and at once turned it to the gold woven for the girl in the fairy story. The pigeons started to peck, the rats to rustle. A big sailing boat, her torn
20 sails wrinkled like ancient skin, came with a just perceptible movement as the current brought her towards us. She was empty, going north. A smaller boat stood south towards us but did little more than stem the current. She was loaded deep with raw, red brick and seemed to have no more than six inches of freeboard.

Alaa appeared, blinking. I asked him what the sailing boats were called. He did not know but put the
25 question to *Reis* Shasli, who was climbing aboard at that moment.

"He says they are called 'Sandals'."

Reis Shasli was bowing sinuously and smiling.

"Please tell him I hope we get further today than we did yesterday."

Alaa translated. Shasli continued to writhe, answered, then swung himself up into the glass box which
30 housed our wheel. Alaa translated. I could not believe what I heard.

"*What?*"

"He who rides the sea of the Nile must have sails woven of patience."

An Egyptian Journal, William Golding

Reis = captain of a boat or vessel

Marks

(a) Account for the word order in the sentence "It was still dark outside and cold" (lines 1–2). **1**

(b) What mood does Golding create in lines 2–5? Justify your answer. **2**

(c) "Were they—were *we* since . . . muscles can operate?" (lines 6–7)

and

"It was as if the night . . . to recover daily." (lines 11–12)

These sentences express similar ideas. Which sentence do you feel to be more effective? Justify your choice. **4**

(d) How is the power and vitality of the sun illustrated in the second paragraph (lines 13–23)? **4**

(e) Comment on the effectiveness of two of the following in describing the scene:

"the first tableau of grief" (lines 15–16)
"in two minutes flat" (line 16)
"The pigeons started to peck, the rats to rustle" (line 19)
"torn sails wrinkled like ancient skin" (lines 19–20). **4**

(f) Examine the techniques by which Golding creates contrasts between the first paragraph (lines 1–12) and the second (lines 13–23).

You should consider such techniques as sentence structure, word choice, imagery, tone, narrative viewpoint or any other appropriate technique. **6**

(g) Comment on the aptness of the imagery used by *Reis* Shasli in the context both of the conversation (lines 26–32) and also with respect to the whole passage. **4**

 (25)

[SECTION B—CLOSE READING OF SPECIFIED TEXTS starts on Page six

SECTION B—CLOSE READING OF SPECIFIED TEXTS

If you have chosen to attempt this Section, you should select only ONE text and answer the questions which follow it.

You should enter the number and the name of the text chosen at the top of the page, and the letter corresponding to each question in the left-hand margin of your answer book.

You are reminded of the instruction on the front cover about the use of texts.

1. *ROMEO AND JULIET*

Read the extract carefully and answer the questions which follow. The number of marks attached to each question will give a clear indication of the length of answer required.

This extract is taken from Act II Scene IV of the play.

	PETER:	I saw no man use you at his pleasure. If I had, my weapon should quickly have been out. I warrant you, I dare draw as soon as another man, if I see occasion in a good quarrel, and the law on my side.
5	NURSE:	Now, afore God, I am so vexed that every part about me quivers. Scurvy knave! Pray you, sir, a word; and, as I told you, my young lady bid me inquire you out. What she bid me say, I will keep to myself. But first let me tell ye, if ye should lead her in a fool's paradise, as they say, it were a very gross kind of behaviour, as they say. For the gentlewoman is young; and therefore, if you should deal double with her, truly it were an ill thing to be offered to any gentlewoman, and very weak dealing.
15	ROMEO:	Nurse, commend me to thy lady and mistress. I protest unto thee—
	NURSE:	Good heart, and i'faith I will tell her as much. Lord, Lord! She will be a joyful woman.
20	ROMEO:	What wilt thou tell her, Nurse? Thou dost not mark me.
	NURSE:	I will tell her, sir, that you do protest, which, as I take it, is a gentlemanlike offer.
25	ROMEO:	Bid her devise Some means to come to shrift this afternoon, And there she shall at Friar Laurence' cell Be shrived and married. Here is for thy pains.
	NURSE:	No, truly, sir. Not a penny.
	ROMEO:	Go to! I say you shall.
	NURSE:	This afternoon, sir? Well, she shall be there.
30	ROMEO:	And stay, good Nurse, behind the abbey wall. Within this hour my man shall be with thee And bring thee cords made like a tackled stair, Which to the high topgallant of my joy Must be my convoy in the secret night.
35		Farewell. Be trusty, and I'll quit thy pains. Farewell. Commend me to thy mistress.

	NURSE:	Now God in heaven bless thee! Hark you, sir.
	ROMEO:	What sayest thou, my dear Nurse?
40	NURSE:	Is your man secret? Did you ne'er hear say, Two may keep counsel, putting one away?
	ROMEO:	Warrant thee my man's as true as steel.
45 50	NURSE:	Well, sir, my mistress is the sweetest lady. Lord, Lord! when 'twas a little prating thing—O there is a nobleman in town, one Paris, that would fain lay knife aboard. But she, good soul, had as lief see a toad, a very toad, as see him. I anger her sometimes, and tell her that Paris is the properer man. But I'll warrant you, when I say so, she looks as pale as any clout in the versal world. Doth not rosemary and Romeo begin both with a letter?
	ROMEO:	Ay, Nurse. What of that? Both with an "R".
55	NURSE:	Ah, mocker! That's the dog's name. "R" is for the— No, I know it begins with some other letter; and she hath the prettiest sententious of it, of you and rosemary, that it would do you good to hear it.
	ROMEO:	Commend me to thy lady.

Exit Romeo

Marks

(a) Peter's speech reflects at least one of the themes in the play. By referring to the speech, identify one of these themes.

2

(b) In lines 5–14 identify **two** features of the Nurse's manner of speaking. What do the features you have identified suggest to you about her personality? Explain how they do this.

4

(c) Briefly explain the confusion which arises between the Nurse and Romeo in lines 15–22.

3

(d) What stage direction might be appropriate between lines 28 and 29? You should briefly justify your choice.

2

(e) What do you judge Romeo's mood to be in lines 30–34? Show how the language conveys this mood.

2

(f) Identify **two** images the Nurse uses in lines 42–50. Explain what the images you have chosen add to your understanding of the restricted nature of the practical, domestic world the Nurse inhabits.

4

(g) To what extent do you think the Nurse provides practical and emotional support for Juliet throughout the play? Justify your answer by reference to relevant scenes.

8

(25)

[Turn over for Text 2—ROBERT BURNS

You are reminded of the instruction on the front cover about the use of texts.

2. ROBERT BURNS

Read the poem carefully and answer the questions which follow. The number of marks attached to each question will give a clear indication of the length of answer required.

TO A LOUSE,
On Seeing one on a Lady's Bonnet
at Church

Ha! whare ye gaun, ye crowlan ferlie!
Your impudence protects you sairly:
I canna say but ye strunt rarely,
 Owre *gawze* and *lace*;
5 Tho' faith, I fear ye dine but sparely,
 On sic a place.

Ye ugly, creepan, blastet wonner,
Detested, shunn'd, by saunt an' sinner,
How daur ye set your fit upon her,
10 Sae fine a *Lady*!
Gae somewhere else and seek your dinner,
 On some poor body.

Swith, in some beggar's haffet squattle;
There ye may creep, and sprawl, and sprattle,
15 Wi' ither kindred, jumping cattle,
 In shoals and nations;
Whare *horn* nor *bane* ne'er daur unsettle,
 Your thick plantations.

Now haud you there, ye're out of sight,
20 Below the fatt'rels, snug and tight,
Na faith ye yet! ye'll no be right,
 Till ye've got on it,
The vera tapmost, towrin height
 O' *Miss's bonnet*.

25 My sooth! right bauld ye set your nose out,
As plump an' gray as onie grozet:
O for some rank, mercurial rozet,
 Or fell, red smeddum,
I'd gie you sic a hearty dose o't,
30 Wad dress your droddum!

I wad na been surpriz'd to spy
You on an auld wife' *flainen toy*;
Or aiblins some bit duddie boy,
 On's *wylecoat*;
35 But Miss's fine *Lunardi*, fye!
 How daur ye do't?

O *Jenny* dinna toss your head,
An' set your beauties a' abroad!
Ye little ken what cursed speed
40 The blastie's makin!
Thae *winks* and *finger-ends*, I dread,
 Are notice takin!

O wad some Pow'r the giftie gie us
To see oursels as ithers see us!
45 It wad frae monie a blunder free us
 An' foolish notion:
What airs in dress an' gait wad lea'e us
 And ev'n Devotion!

		Marks

(*a*) (i) Comment on the effectiveness of the first line as an opening to the poem. **2**

 (ii) Explain why the louse's "impudence" protects it "sairly". **1**

 (iii) Show how Burns's word choice conveys the "impudence" of the louse in lines 3–10. **3**

(*b*) Show how in lines 11–18 Burns makes the situation humorous by using **two** of the following: structure; hyperbole; sound; word choice. **4**

(*c*) Comment on the use Burns makes of references to dress and clothing in Verse 4 (lines 19–24) and Verse 6 (lines 31–36). **4**

(*d*) Show how Burns uses lines 43–48 to moralise. **3**

(*e*) Choose another poem by Burns which comments on human frailty. To what extent do you find his treatment of this theme effective? Justify your answer with close reference to your chosen text. **8**

 (25)

[Turn over for Text 3—*NORTH AND SOUTH*

You are reminded of the instruction on the front cover about the use of texts.

3. *NORTH AND SOUTH*

Read the extract carefully and answer the questions which follow. The number of marks attached to each question will give a clear indication of the length of answer required.

This extract is taken from "Masters and Men".

The walls were pink and gold; the pattern on the carpet represented bunches of flowers on a light ground, but it was carefully covered up in the centre by a linen drugget, glazed and colourless. The window-curtains were lace; each chair and sofa had its own particular veil of netting, or knitting. Great alabaster groups occupied every flat surface, safe from dust under their glass shades. In the middle of
5 the room, right under the bagged-up chandelier, was a large circular table, with smartly-bound books arranged at regular intervals round the circumference of its polished surface, like gaily-coloured spokes of a wheel. Everything reflected light, nothing absorbed it. The whole room had a painfully spotted, spangled, speckled look about it, which impressed Margaret so unpleasantly that she was hardly conscious of the peculiar cleanliness required to keep everything so white and pure in such an
10 atmosphere, or of the trouble that must be willingly expended to secure that effect of icy, snowy discomfort. Wherever she looked there was evidence of care and labour, but not care and labour to procure ease, to help on habits of tranquil home employment; solely to ornament, and then to preserve ornament from dirt or destruction.

They had leisure to observe, and to speak to each other in low voices, before Mrs Thornton appeared.
15 They were talking of what all the world might hear; but it is a common effect of such a room as this to make people speak low, as if unwilling to awaken the unused echoes.

At last Mrs Thornton came in, rustling in handsome black silk, as was her wont; her muslins and laces rivalling, not excelling, the pure whiteness of the muslins and netting of the room. Margaret explained how it was that her mother could not accompany them to return Mrs Thornton's call; but in her anxiety
20 not to bring back her father's fears too vividly, she gave but a bungling account, and left the impression on Mrs Thornton's mind that Mrs Hale's was some temporary or fanciful fine-ladyish indisposition, which might have been put aside had there been a strong enough motive; or that if it was too severe to allow her to come out that day, the call might have been deferred. Remembering, too, the horses to her carriage, hired for her own visit to the Hales, and how Fanny had been ordered to go by Mr Thornton,
25 in order to pay every respect to them, Mrs Thornton drew up slightly offended, and gave Margaret no sympathy—indeed, hardly any credit for the statement of her mother's indisposition.

"How is Mr Thornton?" asked Mr Hale. "I was afraid he was not well, from his hurried note yesterday."

"My son is rarely ill; and when he is, he never speaks about it, or makes it an excuse for not doing
30 anything. He told me he could not get leisure to read with you last night, sir. He regretted it, I am sure; he values the hours spent with you."

"I am sure they are equally agreeable to me," said Mr Hale. "It makes me feel young again to see his enjoyment and appreciation of all that is fine in classical literature."

"I have no doubt that classics are very desirable for people who have leisure. But, I confess, it was
35 against my judgement that my son renewed his study of them. The time and place in which he lives, seem to me to require all his energy and attention. Classics may do very well for men who loiter away their lives in the country or in colleges; but Milton men ought to have their thoughts and powers absorbed in the work of to-day. At least, that is my opinion." This last clause she gave out with 'the pride that apes humility'.

Marks

(a) In what kind of neighbourhood is Mr Thornton's house set? Why does Margaret find this
 surprising? 2

(b) How does the sentence structure and word choice used in lines 1–3 help to imply criticism of the
 drawing room? 4

(c) How does the language of lines 4–7 convey to you the status of books in the household? You
 should consider such features as word choice, imagery, tone or any other appropriate feature. 4

(d) Explain carefully in your own words
 (i) what is meant by the last sentence in the first paragraph (lines 11–13)
 (ii) how the structure of the sentence reinforces the meaning. 4

(e) What motive(s) led to Margaret's giving a "bungling account" (line 20) of her mother's illness? 1

(f) What is the criticism of Mrs Thornton implied by the last sentence of the extract? (lines 38–39) 2

(g) In the last paragraph Mrs Thornton states her views on the opposition between, on the one hand,
 culture and education and, on the other hand, work and trade.

 State what her views are and go on to show to what extent these views are supported or opposed
 by other characters in the novel.

 You should refer to events and incidents throughout the novel to support your answer. 8

 (25)

[Turn over for Text 4—*THE DEVIL'S DISCIPLE*

You are reminded of the instruction on the front cover about the use of texts.

4. *THE DEVIL'S DISCIPLE*

Read the extract carefully and answer the questions which follow. The number of marks attached to each question will give a clear indication of the length of answer required.

Reverend Anderson is visiting Mrs Dudgeon.

ANDERSON: Sister: the Lord has laid his hand very heavily upon you.

MRS DUDGEON: [*with intensely recalcitrant resignation*] It's His will, I suppose; and I must bow to it. But I do think it hard. What call had Timothy to go to Springtown, and remind everybody that he belonged to a man that was being hanged?—and [*spitefully*] that deserved it, if ever a man did.

5

ANDERSON: [*gently*] They were brothers, Mrs Dudgeon.

MRS DUDGEON: Timothy never acknowledged him as his brother after we were married: he had too much respect for me to insult me with such a brother. Would such a selfish wretch as Peter have come thirty miles to see Timothy hanged, do you think? Not thirty yards, not he. However, I must bear my cross as best I may: least said is soonest mended.

10

ANDERSON: [*very grave, coming down to the fire to stand with his back to it*] Your eldest son was present at the execution, Mrs Dudgeon.

MRS DUDGEON: [*disagreeably surprised*] Richard?

ANDERSON: [*nodding*] Yes.

15 MRS DUDGEON: [*vindictively*] Let it be a warning to him. He may end that way himself, the wicked, dissolute, godless—[*she suddenly stops; her voice fails; and she asks, with evident dread*] Did Timothy see him?

ANDERSON: Yes.

MRS DUDGEON: [*holding her breath*] Well?

20 ANDERSON: He only saw him in the crowd: they did not speak. [*Mrs Dudgeon, greatly relieved, exhales the pent up breath and sits at her ease again.*] Your husband was greatly touched and impressed by his brother's awful death. [*Mrs Dudgeon sneers. Anderson breaks off to demand with some indignation*] Well, wasnt it only natural, Mrs Dudgeon? He softened towards his prodigal son in that moment. He sent for him to come to see him.

25

MRS DUDGEON: [*her alarm renewed*] Sent for Richard!

ANDERSON: Yes; but Richard would not come. He sent his father a message; but I'm sorry to say it was a wicked message—an awful message.

MRS DUDGEON: What was it?

30 ANDERSON: That he would stand by his wicked uncle and stand against his good parents, in this world and the next.

MRS DUDGEON: [*implacably*] He will be punished for it. He will be punished for it—in both worlds.

ANDERSON: That is not in our hands, Mrs Dudgeon.

MRS DUDGEON: Did I say it was, Mr Anderson? We are told that the wicked shall be punished. Why
35 should we do our duty and keep God's law if there is to be no difference made between us and those who follow their own likings and dislikings, and make a jest of us and of their Maker's word?

ANDERSON: Well, Richard's earthly father has been merciful to him; and his heavenly judge is the father of us all.

40 MRS DUDGEON: [*forgetting herself*] Richard's earthly father was a softheaded—

 ANDERSON: [*shocked*] Oh!

 MRS DUDGEON: [*with a touch of shame*] Well, I am Richard's mother. If I am against him who has any
 right to be for him? [*Trying to conciliate him*] Wont you sit down, Mr Anderson? I
 should have asked you before; but I'm so troubled.

45 ANDERSON: Thank you. [*He takes a chair from beside the fireplace, and turns it so that he can sit
 comfortably at the fire. When he is seated he adds, in the tone of a man who knows that he
 is opening a difficult subject*] Has Christy told you about the new will?

		Marks

(a) Explain the appropriateness of Anderson's initial comment (line 1). You should refer to both
 tone and content. **2**

(b) (i) Show how lines 2–5 illustrate important aspects of Mrs Dudgeon's personality. **2**

 (ii) In what ways does line 6 establish a contrast between Anderson and Mrs Dudgeon? **2**

 (iii) Go on to show how the contrast between Anderson and Mrs Dudgeon is further developed
 in lines 7–18. **4**

(c) Explain why Anderson's reference to a "prodigal son" in line 24 is appropriate. **2**

(d) "Richard's earthly father was a softheaded . . ." (line 40)

 By referring to the play up to this point, explain the reasons behind Mrs Dudgeon's bitterness. **2**

(e) Comment on the effects of the stage directions in lines 40–47, showing how they help to reveal
 the relationship between Anderson and Mrs Dudgeon. **3**

(f) ". . . he would stand by his wicked uncle and stand against his good parents . . ." (line 30)

 To what extent does Dick live up to the behaviour suggested by this promise? **8**

 (25)

[Turn over for Text 5—*THE INHERITORS*

You are reminded of the instruction on the front cover about the use of texts.

5. *THE INHERITORS*

Read the extract carefully and answer the questions which follow. The number of marks attached to each question will give a clear indication of the length of answer required.

Lok and Fa have returned from looking for food.

"Liku! Liku!"

The bushes twitched again. Lok steadied by the tree and gazed. A head and a chest faced him, half-hidden. There were white bone things behind the leaves and hair. The man had white bone things above his eyes and under the mouth so that his face was longer than a face should be. The man turned

5 sideways in the bushes and looked at Lok along his shoulder. A stick rose upright and there was a lump of bone in the middle.

Lok peered at the stick and the lump of bone and the small eyes in the bone things over the face. Suddenly Lok understood that the man was holding the stick out to him but neither he nor Lok could reach across the river. He would have laughed if it were not for the echo of the screaming in his head.

10 The stick began to grow shorter at both ends. Then it shot out to full length again.

The dead tree by Lok's ear acquired a voice.

"Clop!"

His ears twitched and he turned to the tree. By his face there had grown a twig: a twig that smelt of other, and of goose, and of the bitter berries that Lok's stomach told him he must not eat. This twig

15 had a white bone at the end. There were hooks in the bone and sticky brown stuff hung in the crooks. His nose examined this stuff and did not like it. He smelled along the shaft of the twig. The leaves of the twig were red feathers and reminded him of goose. He was lost in a generalised astonishment and excitement. He shouted at the green drifts across the glittering water and heard Liku crying out in answer but could not catch the words. They were cut off suddenly as though someone had clapped a

20 hand over her mouth. He rushed to the edge of the water and came back. On the other side of the open bank the bushes grew thickly in the flood; they waded out until at their farthest some of the leaves were opening under water; and these bushes leaned over.

The echo of Liku's voice in his head sent him trembling at this perilous way of bushes towards the island. He dashed at them where normally they would have been rooted on dry land and his feet

25 splashed. He threw himself forward and grabbed at the branches with hands and feet. He shouted:

"I am coming!"

Half-lying, half-crawling, grinning all the time with fear he moved out over the river. He could see the wetness down there, mysterious and pierced everywhere by the dark and bending stems. There was no place that would support his whole weight. He had to spread it not only through all his limbs and body

30 but be always in two places, moving, moving as the boughs gave. The water under him darkened. There were ripples on the surface behind each bough, weed caught and fluttering lengthwise, random flashes of the sun below and above. He came to the last tall bushes that were half-drowned and hung over the bed of the river itself. For a moment he saw a stretch of water and the island. He glimpsed the pillars of spray by the fall, saw the rocks of the cliff. Then, because he no longer moved, the branches

35 began to bend under him.

They swayed outwards and down so that his head was lower than his feet. He sank, gibbering, and the water rose, bringing a Lok-face with it. There was a tremble of light over the Lok-face but he could see the teeth. Below the teeth, a weed-tail was moving backwards and forwards, more than the length of a man each time. But everything else under the teeth and the ripple was remote and dark. A breeze blew

40 along the river and the bushes swayed gently sideways. His hands and feet gripped painfully of themselves and every muscle of his body was knotted. He ceased to think of the old people or the new people. He experienced Lok, upside down over deep water with a twig to save him.

Marks

(*a*) "Liku! Liku!" (line 1)

Explain why Lok seems to be anxious to contact Liku. **1**

(*b*) (i) By commenting on the word choice and imagery used in lines 2–6 show how Golding conveys Lok's perception of what is happening. **4**

 (ii) The people rely a great deal on their senses. Show how Golding illustrates this point in lines 11–17. **4**

(*c*) (i) Comment on **one** example from any other part of the novel where the people's fear of water is significant. **2**

 (ii) Choose **three** of the following quotations and show how effectively each conveys Lok's fear.

 "grinning all the time with fear" (line 27)
 "pierced everywhere by the dark and bending stems" (line 28)
 "He sank, gibbering" (line 36)
 "a tremble of light over the Lok-face" (line 37)
 "the ripple was remote and dark" (line 39) **6**

(*d*) "He experienced Lok, upside down over deep water with a twig to save him." (line 42)

By referring briefly to the extract, explain how Lok's physical position as it is described here is symbolic. Then show how symbolism is used to convey the author's ideas effectively in other parts of the novel. **8**

(25)

[Turn over for Text 6—IAIN CRICHTON SMITH

You are reminded of the instruction on the front cover about the use of texts.

6. IAIN CRICHTON SMITH

Read the poem carefully and answer the questions which follow. The number of marks attached to each question will give a clear indication of the length of answer required.

THE TV

(1)

The sun rises every day
from moving shadows—
on the TV.

(2)

We did not believe in the existence of Ireland
till we saw it many nights—
on the TV.

(3)

He knows more about Humphrey Bogart
than he knows about Big Norman—
since he got the TV.

(4)

Said Plato—
"We are tied in a cave"—
that is, the TV.

(5)

A girl came into the room
without perfume without expression—
on the TV.

(6)

At last he lost the world
As Berkeley said—
there was nothing but the TV.

(7)

He bought "War and Peace",
I mean Tolstoy,
after seeing it on the TV.

(8)

When he switched off the TV
the world went out—
he himself went out.

(9)

His hands did not come back to him
or his eyes
till he put on the TV.

(10)

A rose in a bowl on the TV set,
the things that are not in the world,
the things that are not.

(11)

He found himself in the story.
He was in the room.
He didn't know where he was.

(12)

You, my love, are dearer to me
than Softly Softly
than Sportsnight with Coleman.

(13)

"In locked rooms with iron gates"—
but my love,
do they have TV?

Marks

(*a*) Comment on the significance of the layout of the poem. 2

(*b*) Show how the structure of the verse form in verses 1–6 helps to convey the poet's attitude to television. 3

(*c*) By reference to both structure and meaning, show in what ways verse 8 is a turning point in the poem. 2

(*d*) In verse 11, what impression is created of the man? Justify your answer. 2

(*e*) Much of this poem relies on allusion (a reference to a person, event, place, work of literature, etc, which the reader is expected to understand).

Explain and comment on the effectiveness of allusion in any **two** of the following verses: 2, 3, 4, 6, 7. 4

(*f*) Comment fully on the significance of the last verse. 4

(*g*) In many of Crichton Smith's poems, it can be helpful to have a knowledge of "background" details (eg from history, culture, religion, literature . . .).

Referring closely to no more than two other poems by Crichton Smith, discuss to what extent this knowledge enhances or detracts from your appreciation of the poetry. 8

(25)

[Turn over for Text 7—*BOLD GIRLS*

You are reminded of the instruction on the front cover about the use of texts.

7. *BOLD GIRLS*

Read the extract carefully and answer the questions which follow. The number of marks attached to each question will give a clear indication of the length of answer required.

The extract is from scene one, near the beginning of the play.

> *Marie bursts into the room with her arms laden with four packets of crisps, two of Silk Cut and a packet of chocolate biscuits. She is cheerful, efficient, young. She drops one of the crisps, tuts in exasperation, and looks at it.*

5 MARIE (*shouting back out the door*): Mickey! Mickey were you wanting smoky bacon? . . . Well this is salt and vinegar . . . Well, why did you not say? Away you and swap this . . . Catch now. (*She hurls the bag*) No you cannot . . . No . . . because you'll not eat your tea if you do! (*At the doorway*) Mickey, pick up those crisps and don't be so bold.

> *Marie comes back into the room and starts two jobs simultaneously. First she puts the crisps etc away, then she fills a pan with water and throws it on the stove. She starts sorting her dry washing into what needs*
10 *ironing and what doesn't; she sorts a few items then starts peeling potatoes; all her movements have a frenetic efficiency.*

> *Nora enters with a pile of damp sheets. She is down-to-earth, middle-aged.*

NORA: Is that the last of them, Marie?

MARIE: Just the towels . . . Oh Nora, you didn't need to carry that over, wee Michael was coming to get
15 them.

NORA: Och you're all right. These towels is it?

MARIE: That's them.

NORA: This'll need to be the last. I've a load of my own to get in.

MARIE: Oh here Nora, leave them then!

20 NORA: No, no, we're best all getting our wash done while it's dry. We'll wait long enough to see the sun again.

> *Cassie sticks her head round the door. She is Nora's daughter, sceptical, sharp-tongued.*

CASSIE: Can I ask you a personal question, Marie?

NORA: Have you left that machine on, Cassie?

25 CASSIE: Do you have a pair of red knickers?

MARIE: I think I do, yes.

CASSIE: With wee black cats, with wee balloons coming out their mouths saying "Hug me, I'm cuddly"?

MARIE: (*stops peeling potatoes briefly; giving Cassie a severe look*) They were in a pack of three for ninety-nine pence.

30 NORA: You see if you leave it, it just boils over, you know that Cassie.

CASSIE: And did you put those knickers in the wash you just gave my mother?

NORA: It's because that powder isn't really biological, it's something else altogether.

MARIE: What's happened to them?

NORA: I think it's for dishwashers. But it was in bulk, cheap you know? I got a load of it at the club last
35 month, awful nice young man, do you know that Dooley boy?

CASSIE: And did my mummy just drop those bright red knickers with their wee cats, right in the middle of the road, right by the ice cream van, as she was coming across from our house to yours?

NORA: Did I what?

MARIE: Oh *no*! (*She increases the pace of her peeling*)

40 NORA: Cassie, will you get back over the road and see to that machine before the foam's coming down the steps to greet us.

MARIE: Where are they?

CASSIE: At the top of the lamp-post. I didn't know wee Colm could climb like that, he's only nine.

NORA: Och I'll do it myself. (*She moves to exit with a heap of towels*)

45 MARIE: Hold on Nora, I'm coming too.

CASSIE: I wouldn't. After what's been said about those knickers I'd just leave them alone, pretend you never saw them in your life.

NORA: All my lino's curled after the last time. I'll never find a colour like that again.

Nora exits.

		Marks
(a)	What happens on stage immediately before this extract?	2
(b)	Show how the stage directions in lines 1–3 help to create an impression of Marie's lifestyle.	2
(c)	Explain how various linguistic features of the dialogue in lines 4–21 help create the impression of everyday speech.	4
(d)	What dramatic use is being made of Marie's actions in lines 9–11, 28 and 39?	3
(e)	In lines 24–37, Nora's speeches are being ignored by Marie and Cassie. What dramatic effects does this achieve?	4
(f)	Show how either of Cassie's last two speeches in the extract (line 43 or lines 46–47) reveals an important aspect of her character.	2
(g)	This extract concentrates on details of everyday domestic life. Show, by referring in detail to other parts of the play, that the playwright explores themes which go beyond such details.	8
		(25)

[Turn over for Text 8—*SUNSET SONG*

You are reminded of the instruction on the front cover about the use of texts.

8. *SUNSET SONG*

Read the extract carefully and answer the questions which follow. The number of marks attached to each question will give a clear indication of the length of answer required.

The extract is taken from "Ploughing".

So that was the college place at Duncairn, two Chrisses went there each morning, and one was right douce and studious and the other sat back and laughed a canny laugh at the antics of the teachers and minded Blawearie brae and the champ of horses and the smell of dung and her father's brown, grained hands till she was sick to be home again. But she made friends with young Marget Strachan,
5 Chae Strachan's daughter, she was slim and sweet and fair, fine to know, though she spoke about things that seemed awful at first and then weren't awful at all and you wanted to hear more and Marget would laugh and say it was Chae that had told her. Always as Chae she spoke of him and that was an unco-like thing to do of your father, but maybe it was because he was socialist and thought that Rich and Poor should be Equal. And what was the sense of believing that and then sending his daughter to educate
10 herself and herself become one of the Rich?

But Marget cried that wasn't what Chae intended, she was to learn and be ready for the Revolution that was some day coming. And if come it never did she wasn't to seek out riches anyway, she was off to be trained as a doctor. Chae said that life came out of women through tunnels of pain and if God had planned woman for anything else but the bearing of children it was surely the saving of them.

15 And Marget's eyes, that were blue and so deep they minded you of a well you peeped into, they'd grow deeper and darker and her sweet face grow so solemn Chris felt solemn herself. But that would be only a minute, the next and Marget was laughing and fleering, trying to shock her, telling of men and women, what fools they were below their clothes; and how children came and how you should have them; and the things that Chae had seen in the huts of the blacks in Africa. And she told of a place
20 where the bodies of men lay salted and white in great stone vats till the doctors needed to cut them up, the bodies of paupers they were—*so take care you don't die as a pauper, Chris, for I'd hate some day if I rang a bell and they brought me up out of the vat your naked body, old and shrivelled and frosted with salt, and I looked in your dead, queer face, standing there with the scalpel held in my hand, and cried "But this is Chris Guthrie!"*

25 That was awful, Chris felt sick and sick and stopped midway the shining path that led through the fields to Peesie's Knapp that evening in March. Clean and keen and wild and clear, the evening ploughed land's smell up in your nose and your mouth when you opened it, for Netherhill's teams had been out in that park all day, queer and lovely and dear the smell Chris noted.

And something else she saw, looking at Marget, sick at the thought of her dead body brought to Marget.
30 And that thing was a vein that beat in Marget's throat, a little blue gathering where the blood beat past in slow, quiet strokes, it would never do that when one was dead and still under grass, down in the earth that smelt so fine and you'd never smell; or cased in the icy darkness of a vat, seeing never again the lowe of burning whins or hearing the North Sea thunder beyond the hills, the thunder of it breaking through a morning mist, the right things that might not last and so soon went by. And they only were
35 real and true, beyond them was nought you might ever attain but a weary dream and that last dark silence—Oh, only a fool loved being alive!

But Marget threw her arms around her when she said that, and kissed her with red, kind lips, so red they were that they looked like haws, and said there were lovely things in the world, lovely that didn't endure, and the lovelier for that.

Marks

(a) By referring to lines 1–4, explain the meaning of the phrase "two Chrisses" (line 1). 2

(b) By referring to lines 4–6 ("But she made . . . wanted to hear more"), give **two** reasons which
 explain why Chris is attracted to Marget. 2

(c) Comment fully on the relationship between Chae and Marget Strachan. In your answer, you
 should refer to lines 5–14 ("though she spoke . . . the saving of them."). 4

(d) Show how word choice and sentence structure in lines 19–24 contribute to the shock effect of
 Marget's story. 4

(e) (i) "Oh, only a fool loved being alive!" (line 36)
 By referring to lines 29–36, explain the train of thought which leads to Chris's statement. 4

 (ii) Explain what Marget means by "lovely things in the world, lovely that didn't endure, and
 the lovelier for that." (lines 38–39) 1

(f) Choose a character other than Marget who has a significant influence on the development of
 Chris Guthrie's personality. By referring to one, or more than one, part of the novel, show how
 this character has such an effect. 8

 (25)

[Turn over for Text 9—PHILIP LARKIN

You are reminded of the instruction on the front cover about the use of texts.

9. PHILIP LARKIN

Read the poem carefully and answer the questions which follow. The number of marks attached to each question will give a clear indication of the length of answer required.

AMBULANCES

[handwritten: physical ambulance]
[handwritten: secrecy] *[handwritten: - sins and privacy]*

Closed like confessionals, they thread *[handwritten: weave]*
Loud noons of cities, giving back *[handwritten: busiest time]*
None of the glances they absorb. *[handwritten: see out - but not in]*
Light glossy grey, arms on a plaque,
5 They come to rest at any kerb:
All streets in time are visited. *[handwritten: no escape]*

Then children strewn on steps or road,
Or women coming from the shops *[handwritten: everybody can be involved]*
Past smells of different dinners, see
10 A wild white face that overtops *[handwritten: detachment - just face]*
[handwritten: hide blood →] Red stretcher-blankets momently
[handwritten: not human - luggage] As it is carried in and stowed,

And sense the solving emptiness
That lies just under all we do,
15 And for a second get it whole,
So permanent and blank and true.
The fastened doors recede. *Poor soul*, *[handwritten: cruel]*
They whisper at their own distress;

For borne away in deadened air *[handwritten: silent]*
20 May go the sudden shut of loss
Round something nearly at an end, *[handwritten: a life]*
And what cohered in it across
The years, the unique random blend
Of families and fashions, there
25 At last begin to loosen. Far *[handwritten: connections]*
From the exchange of love to lie
[handwritten: sad] Unreachable inside a room
The traffic parts to let go by *[handwritten: special journey]*
Brings closer what is left to come,
30 And dulls to distance all we are.

10 January 1961

Marks

(*a*) (i) What impression of ambulances does Larkin convey in lines 1–6? 1

 (ii) By reference to one example of imagery and one feature of sentence structure in these lines, show how he establishes this impression. 4

(*b*) Comment on how Larkin emphasises the contrast between the scenes described in lines 7–9 and lines 10–12. 2

(*c*) "And sense the solving . . .
 . . . and blank and true." (lines 13–16)

 Explain how these lines play a significant part in the development of the poem's theme. 4

(*d*) "*Poor soul,*
They whisper at their own distress;" (lines 17–18)

 (i) In what way(s) might these lines surprise the reader? 2

 (ii) Show how Larkin makes clear in lines 19–30 the reason for their "distress". You should comment on two techniques such as: sentence structure; word choice; imagery; rhythm. 4

(*e*) Comment briefly on how effectively Larkin brings this poem to a conclusion.

 By referring in some detail to theme(s) and techniques, give your views on the effectiveness of the conclusion of one other poem by Larkin. 8

 (25)

[Turn over for PART 2—CRITICAL ESSAY

PART 2—CRITICAL ESSAY

Attempt ONE question only, taken from any of the Sections A to D.

In all Sections you may use Scottish texts.

You should spend about 50 minutes on this part of the paper.

Begin your answer on a fresh page.

If you use a Specified Text as the basis for your Critical Essay, you must not rely ONLY on any extract printed in Part 1 in this paper. If you attempt Section C—Poetry, you should note the additional instruction at the head of Section C.

SECTION A—DRAMA

If you have answered on a play in the Specified Text option in Part 1 of the paper, you must not attempt a question from this Drama Section.

In your answer in this Section you should, where relevant, refer to such features as dialogue, characterisation, plot, theme, scene, climax, style, structure.

1. What do you consider to be a turning point in a Shakespeare play you have studied? Justify your choice by referring to such features as character development, decisions, theme(s), mood, dénouement.

2. From a play you have studied, choose a scene in which a character is forced to face up to the truth about himself/herself.

 Briefly explain the circumstances which bring this about and go on to consider how it affects the outcome of the play and your response to the character.

3. Choose a play which could unsettle or even shock an audience, because it deals with controversial ideas.

 Explain, with close reference to the text, what theme(s) or issue(s) the playwright is exploring, and how the way that he/she explores them could have this effect on an audience.

4. Choose an important scene in a play that you have seen in performance, and explain how it was staged in such a way as to highlight important themes.

 You may wish to refer to: stage business, costume, lighting, props, director's input, music.

5. Choose a play in which at some point in the action one character attempts to manipulate another.

 Examine the character's motives and methods, and show how the outcome of the attempt is important for the play as a whole.

SECTION B—PROSE

If you have answered on a prose work in the Specified Text option in Part 1 of the paper, you must not attempt a question from this Prose Section.

In your answer in this Section you should, where relevant, refer to such features as setting, theme, characterisation, plot, content, style, structure, language, narrative stance, symbolism.

6. Choose a novel in which a character makes a sacrifice **or** a discovery **or** a mistake.

 Show why the character's action is important in the novel.

 You may wish to refer to theme, character development, plot development, narrative viewpoint.

7. The novelist Robin Jenkins has written that "fiction ought to create credible characters, in situations that are moving and in some way illuminating".

 How well does a novel or short story that you have studied fit this description?

8. Choose a work of non-fiction, and show by referring closely to the text how the writer has enhanced your understanding of his/her ideas.

9. Choose a novel or short story in which a child or adolescent character plays an important part.

 Discuss how the writer uses this character to develop the theme(s) of the novel or short story.

10. Examine in detail how a novelist presents the first appearance of a major character. Go on to discuss how effectively this prepares you for the rôle of the character in the remainder of the novel.

SECTION C—POETRY

If you have answered on a poem in the Specified Text option in Part 1 of the paper, you must not attempt a question from this Poetry Section. You may not base an answer on Burns's "To a Louse", Crichton Smith's "The TV" or Larkin's "Ambulances".

In your answer in this Section you should, where relevant, refer to such features as rhyme, rhythm, word choice, language, sound, imagery, symbolism, style, structure.

11. Choose a poem which deals with a person who is one of the following: an outcast; in distress; in love; dominant; shy.

 Show how the poet uses language to reveal the personality.

12. Consider the impact of the last few lines of a poem you have studied.

 Referring closely to the language of the whole poem, examine how well these lines act as a conclusion to the whole poem.

13. How much does sound contribute to the success of a poem you have studied?

14. With the millennium approaching, nominate a poet who you think says something vitally important about an aspect of twentieth century life.

 Justify your choice by examining both what the poet is saying and the poetic techniques used in one **or** two of his/her poems.

[Turn over for SECTION D—MASS MEDIA

SECTION D—MASS MEDIA

If your Review of Personal Reading is based entirely on a radio, television or film script, you must not attempt a question from this Mass Media Section.

15. Show how a particular sequence in a film explores a relationship involving one of the central characters. You may wish to refer to mise-en-scène, montage, soundtrack.

16. Choose a film which has been targeted at a particular audience. By referring to key aspects of the film, show how successful it is in meeting the needs and tastes of this audience.

17. "Now that feminists have won all those earlier debates, they find women being pushed into new stereotypes—but they're still unacceptable!"

 Show how these "new stereotypes" of women are constructed in media texts. By referring to one or more than one text, explain how acceptable you find these stereotypes.

18. By referring to one or more than one text, show how an impression of authority is constructed. You may choose the representation of an individual, an institution, or a group in society.

19. The Classics Revived. Choose a recent television version of a "classic" text, and discuss the appeal of this version to a modern audience.

20. By close analysis of a television drama or serial or series with which you are familiar, show how plot, setting and character are used to explore a topical theme.

[END OF QUESTION PAPER]

[BLANK PAGE]

[BLANK PAGE]

[C039/SQP072]

HIGHER ENGLISH

Paper I

Specimen Question Paper

Time: 1 hour 30 minutes

NATIONAL QUALIFICATIONS

You should attempt all questions.

The total value of the Paper is 60 marks.

INTERPRETATION

There are TWO passages and questions.

Read the passages carefully and then answer all the questions which follow. **Use your own words whenever possible and particularly when you are instructed to do so.**

> You should read it to:
>
> understand what the author is saying about childhood experience and its influence on him as a writer (**Understanding—U**);
>
> analyse his choice of language, imagery and structures to recognise how they convey his point of view and contribute to the impact of the passage (**Analysis—A**);
>
> evaluate how effectively he has achieved his purpose (**Evaluation—E**).

A code letter, (U, A, E) is used alongside each question to give some indication of the skills being assessed. The number of marks attached to each question will give some indication of the length and kind of answer required.

PASSAGE 1

In the passage below, William McIlvanney, author of the novel "Docherty", remembers his upbringing and considers its significance in his development as a writer.

I remember as a boy being alone in the living-room of our council-house in Kilmarnock. I would be maybe 11 years old. I was lying in front of the coal fire with my head resting on an armchair. It was, I think, late on a winter afternoon. The window had gone black and I hadn't put the light on, enjoying the small cave of brightness and heat the fire had hewn from the dark. Perhaps I was a far traveller resting by his camp-fire.
5 Perhaps I was a knight keeping vigil for the dawn when wondrous deeds would be done. For I could be many people at that time as I still can.

I don't know how I came to be alone at that time in that place. In our house with six not unnoticeable presences, it wasn't an easy trick to be alone, even without counting the cavalcade of aunties and uncles and cousins and friends who seemed to be constantly passing through. I wonder if I had come home from school to find the
10 house empty. But that seems improbable. My mother was a ferocious carer who had an almost mystical capacity to conjure solid worries out of air that to the rest of us looked untroubled and clear. Maybe somebody else was supposed to be with me and had gone out briefly.

I don't know. I am simply aware of myself there. The moment sits separate and vivid in my memory, without explanation, like a rootless flower. Whoever I was being, traveller or knight, I must have been tired. For I fell
15 asleep.

The awakening was strange. I think I must have been aware of the noise of people entering the house, one of those slow fuses of sound that sputteringly traverses the unconscious until it ignites into waking. My consciousness and the room came into the light together. My eyes were bruised with brightness. What I saw seems in retrospect to have had the shiningness of newly minted coins, all stamped unmistakably as genuine,
20 pure metal, the undepreciable currency of my life.

What I saw in fact was pretty banal. My father had his hand on the light-switch he had just pressed. My mother was beside him. They were both laughing at what must have been my startled eyes and my wonderment at being where I was. Around them was a room made instantly out of the dark. It was a very ordinary room. But it was wonderful. How strange the biscuit barrel was where my mother kept the rent-money. How unimaginable was
25 the image of Robert Burns with the mouse, painted on glass by my uncle. How incorrigibly itself the battered sideboard became. The room was full of amazing objects. They might as well have come from Pompeii.

And at the centre of them were two marvellously familiar strangers. I saw them not just as my mother and father. I knew suddenly how dark my father was, how physical his presence. His laughter filled the room, coming from a place that was his alone. My mother looked strangely young, coming in fresh-faced from the cold and
30 darkness, her irises swallowing her pupils as she laughed in the shocking brightness. I felt an inordinate love for them. I experienced the transformation of the ordinary into something powerfully mysterious.

I'm convinced that that moment in the living-room at St Maurs Crescent is one of the experiences from which *Docherty* (and perhaps everything I've written) grew. It was a moment which has had many relatives. When I consider them, I realise that they have several features in common.

35 One of them is a belief in the grandeur of the everyday, where the ordinary is just the unique in hiding. As it says in *Docherty*, "messiahs are born in stables". That being so, as a boy I kept finding Bethlehem round every corner. So many things amazed me.

There were the stories surrounding me, for a start. *Docherty*, I should think, began its gestation in the mouths of the people all around me. Our house was an incredible talking-shop. As the youngest of four, I seem to have
40 grown up with an intense conversation going on endlessly about me as my natural habitat. By one of those casually important accidents of childhood, the youngest of us had to sleep in a fold-down bed in the living-room. Lack of space had its advantages. This meant that from a very early age, I could be involved, however marginally, in these debates, often going to sleep with the sound of disputation as a lullaby.

To this continuing seminar on life and the strange nature of it came many visiting speakers. Our house often felt
45 to me like a throughway for talk. Relatives and friends were always dropping in. They brought news of local doings, bizarre attitudes, memorable remarks made under pressure, anecdotes of wild behaviour. Most of it was delivered and received with a calmness that astonished me. I vaguely sensed, early on, the richness they were casually living among, rather as if a traveller should come upon the Incas using pure gold as kitchen utensils. The substance that would be *Docherty* was beginning to glint for me in fragments of talk and caught glimpses of
50 living.

Cognate to my awareness of the rich and largely uncommemorated life around me was a fascination with language. Given my background, I was lucky to be in a house where books were part of the practical furniture, not there as ornaments but to be read and talked about. My mother was the source of the activity. My sister and my two brothers had established reading as a family tradition by the time I was old enough to join in. Only my
55 father, someone—it has always seemed to me—educated spectacularly below his abilities, was never to be comfortable with books. His presence on the edges of our immersion in reading became, I think, in some way formative for me. I wanted him somehow to be included in the words.

Love of reading led naturally, it seemed at the time, to efforts at writing. If books were not the most sought-after domestic adjuncts in our housing scheme (depraved orgies of poetry-reading behind closed curtains), the desire
60 to actually write poetry could have been construed as proof of mental aberration. But this was my next move, one I effected without being ostracised by my peers because, perhaps, I was also very good at football. Having successfully undergone my masculine rites of passage in the West of Scotland, I could indulge in a little limp-wristed scribbling.

Here again the family situation helped. No one—least of all my father (despite being uninterested in books)—
65 ever questioned the validity of the time I spent arranging words on pieces of paper. I took such tolerance for granted. It was only much later I realised how different it might have been for a working-class boy with ambitions to write. A woman writer-friend told me some years ago of a man she knew who came from a background similar to my own. He was bedevilled by a longing to write plays, much to the embarrassment of his relatives. On one occasion an older brother beat him up severely in an attempt to bring him to his senses and to
70 get him to stop inflicting shame upon the family. Such an attitude had been unimaginable to me in my boyhood.

PASSAGE 2

In this passage, writer and actor Alan Bennett reflects on the ways in which books and parents influenced his childhood and career.

You should read it to:

understand Alan Bennett's view of the relationship between the world of books and real life (**Understanding—U**);

analyse how he has conveyed this point of view, using humour and tone (**Analysis—A**);

evaluate the effectiveness of the passage by comparison with the previous one by McIlvanney (**Evaluation—E**).

"What you want to be," Mam said to my brother and me, "is gentleman farmers. They earn up to £10 a week." This was in Leeds some time in the early years of the war, when my father, a butcher at Armley Lodge Road Co-op, was getting £6 a week and they thought themselves not badly off. So it's not the modesty of my mother's aspirations that seems surprising now but the direction. Why gentleman farmers? And the answer, of course,
5 was books.

I had read quite a few story-books by this time, as I had learned to read quite early by dint, it seemed to me, of staring over my brother's shoulder at the comic he was reading until suddenly it made sense. Though I liked reading (and showed off at it), it was soon borne in upon me that the world of books was only distantly related to the world in which I lived. The families I read about were not like our family (no family ever quite was). These
10 families had dogs and gardens and lived in country towns equipped with thatched cottages and mill-streams, where the children had adventures, saved lives, caught villains, and found treasures before coming home, tired but happy, to eat sumptuous teas off chequered tablecloths in low-beamed parlours presided over by comfortable pipe-smoking fathers and gentle aproned mothers, who were invariably referred to as Mummy and Daddy.

15 In an effort to bring this fabulous world closer to my own, more threadbare, existence, I tried as a first step substituting "Mummy" and "Daddy" for my usual "Mam" and "Dad", but was pretty sharply discouraged. My father was hot on anything smacking of social pretension; there had even been an argument at the font because my aunties had wanted my brother given two Christian names instead of plain one.

Had it been only stories that didn't measure up to the world it wouldn't have been so bad. But it wasn't only
20 fiction that was fiction. Fact too was fiction, as textbooks seemed to bear no more relation to the real world than did the story-books. At school or in my *Boy's Book of the Universe* I read of the minor wonders of nature,—the sticklebacks that haunted the most ordinary pond, the newts and toads said to lurk under every stone, and the dragon-flies that flitted over the dappled surface. Not, so far as I could see, in Leeds. There were owls in hollow trees, so the nature books said, but I saw no owls and hollow trees were in short supply too. It was only in the
25 frog-spawn department that nature actually lined up with the text. Even in Leeds there was that, jamjars of which I duly fetched home to stand beside great wilting bunches of bluebells on the backyard window-sill. But the tadpoles never seemed to graduate to the full-blown frogs the literature predicted, invariably giving up the ghost as soon as they reached the two-legged stage when, unbeknownst to Mam, they would have to be flushed secretly down the lav.

30 This sense of deprivation, fully developed by the time I was seven or eight, sometimes came down to particular words. I had read in many stories, beginning I suppose with *Babes in the Wood*, how the childish hero and heroine, lost in the forest, had nevertheless spent a cosy night bedded down on *pine needles*. I had never come across these delightfully accommodating features and wondered where they were to be found. Could one come across them in Leeds? It was not short on parks after all—Gott's Park, Roundhay Park—surely one of them
35 would have pine needles.

And then there was *sward*, a word that was always cropping up in *Robin Hood*. It was what tournaments and duels were invariably fought on. But what was sward? "Grass" said my teacher, Miss Timpson, shortly; but I knew it couldn't be. Grass was the wiry, sooty stuff that covered the Ree in Moorfield Road where we played at night after school. That was not sward. So once, hearing of some woods in Bramley, a few miles from where we
40 lived, I went off on the trail of sward, maybe hoping to come across pine needles in the process. I trailed out past the rhubarb fields at Hill Top, over Stanningly Road then down into the valley that runs up from Kirkstall Abbey. But all I found were the same mouldy old trees and stringy grass that we had at Armley.

Sticklebacks, owls, hollow trees, pine needles and sward—they were what you read about in books; books which were borrowed from Armley Junior Library, and an institution more intended to discourage children from
45 reading could not have been designed. It was presided over by a fierce British Legion commissionaire, a relic of the Boer War, who with his medals and walrus moustache was the image of Hindenberg as pictured on German stamps in my brother's album.

The few books we actually owned were, in fact, largely reference books, bought by subscription through magazines: *Enquire Within*, *What Everybody Wants to Know* and, with its illustrations of a specimen man and
50 woman (minus private parts), *Everybody's Home Doctor*. Mam, admittedly, sometimes sought her own particular brand of genteel escape—sagas of couples who had thrown up everything to start a small-holding (gentleman-farmers in the making).

My parents always felt that had they been educated, had they been "real readers", their lives and indeed their characters would have been different. They imagined books would make them less shy and (always an
55 ambition) able to "mix". Quiet and never particularly gregarious, they cherished a lifelong longing to "branch out", with books somehow the key to it. This unsatisfied dream they have bequeathed to me, so that without any conscious intention I find I am often including in plays or films a scene where a character shows a desire to enter a prestigious world dominated by books. As for me, while I'm not baffled by books, I can't see how anyone can love them ("He loved books"). I can't see how anyone can "love literature". What does that mean? Of course
60 one advantage to being a gentleman farmer is that you seldom have to grapple with such questions.

Questions on Passage 1

Marks

(a) Drawing your information from the second paragraph (lines 7–12), give in your own words a reason
why it was unusual for the author, as a boy, to be alone in the house. **1 U**

(b) (i) Show how in lines 13–15 the author reinforces the significance of the moment described in the
previous paragraphs.

In your answer you should refer to **one** of the following: sentence structure; imagery; word
choice; tense. **2 A**

(ii) Choose **one** of the extended images contained in lines 16–20 and show how effective you find it
in describing the boy's awakening. **2 E**

(iii) "What I saw in fact was pretty banal." (line 21)

Explain how lines 21–24 ("My father . . . was wonderful.") help you to arrive at the meaning of
"banal". **2 U**

(c) (i) By referring to specific words and phrases, explain fully the part lines 32–34 play in the structure
of the passage as a whole. **3 A**

(ii) Explain how lines 35–37 help you to arrive at the meaning of "the ordinary is just the unique in
hiding" (line 35). **2 U**

(d) (i) From lines 38–43, give one feature of the author's home life which ensured that he encountered
a wide variety of language. **1 U**

(ii) In your own words, explain why the boy was "astonished" (line 47). **1 U**

(iii) In lines 44–50, the author uses imagery to convey the special contribution made by his home to
his future career.

By referring to one, or more than one, example, show how effective you find his use of this
technique. **2 A/E**

(e) (i) What is the tone of "If books were not the most sought-after domestic adjuncts in our housing-
scheme . . ." (lines 58–59)? **1 A**

(ii) From the rest of the sentence select a feature of sentence structure **or** word choice which
contributes to that tone and explain how it does so. **2 A**

(f) To what extent do you find the anecdote related in lines 66–70 ("It was only . . . in my boyhood") a
suitable conclusion to this passage?

Justify your view by referring to the whole passage. **4 E**

 (23)

(g) Drawing your information from line 38 to the end of the passage, write a paragraph in which you
summarise the main factors which had a positive influence on William McIlvanney's development as
a writer.

Use your own words as far as possible. **(6) U**

Questions on Passage 2

Marks

(*h*) Give **two** reasons why the writer's mother suggested that he should become a "gentleman-farmer". You should refer to lines 1–5 and lines 50–52 in your answer. **2 U**

(*i*) (i) Explain briefly in your own words the writer's view about "the world of books" (line 8) and his own life. **2 U**

 (ii) By referring fully to lines 15–18, explain how the writer develops this view in a humorous way. **4 U/A**

(*j*) (i) "Fact too was fiction . . ." (line 20)

 Show how lines 19–21 help you to arrive at the meaning of this statement. **2 U**

 (ii) By referring to any part of lines 21–29, show briefly how the writer develops in a humorous way his idea that "Fact too was fiction". **2 U/A**

(*k*) Look again at lines 30–42 ("This sense of deprivation . . . we had at Armley.")

Show how effective you find this section of the passage.

You should refer to ideas and tone in your answer. **4 E/A**

(*l*) (i) Explain in your own words the "unsatisfied dream" (line 56) of the writer's parents and the part that books played in it. You should refer to lines 53–56 in your answer. **2 U**

 (ii) By referring to lines 56–59 ("This unsatisfied . . . does that mean?"), explain how his parents' feelings about books have affected the writer and his work. **3 U**

 (21)

Question on both Passages

(*m*) Which passage do you find more interesting?

Compare the two passages in terms of their main ideas **and** such stylistic features as point of view, tone, imagery, structure . . . **(10) E/A**

 Total (60)

[END OF QUESTION PAPER]

HIGHER ENGLISH

Time: 1 hour 30 minutes

NATIONAL QUALIFICATIONS

Paper II

Specimen Question Paper

There are **two parts** to this paper and you should attempt both parts.

Part 1 (Textual Analysis) is worth 30 marks.

In Part 2 (Critical Essay), you should attempt **one** question only, taken from any of the Sections A–D.

Your answer to Part 2 should begin on a fresh page.

Each question in Part 2 is worth 30 marks.

NB You must not use, in Part 2 of this paper, the same text(s) as you have used in your Specialist Study.

SCOTTISH
QUALIFICATIONS
AUTHORITY
©

PART 1 (TEXTUAL ANALYSIS)

You should spend approximately 45 minutes on this part of the paper.

WAITING ROOM

She waits neatly, bone-china thin,
in a room tight with memories,
claustrophobic with possessions,
rendered down from eighty years,
5 eight Homes and Gardens rooms.

She waits graciously, bearing
the graffiti of age. She drizzles
sherry into fine glasses, tea
into what is left
10 of wide-brimmed wedding china.

With the top of her mind
she is eager to skim off news
of the family, who married whom
and when. Names elude her. Tormented,
15 she tries to trap them on her tongue.

She waits defiantly, fumbling
to light a cigarette, veins
snaking across her hands
like unravelled knitting. A man's face,
20 preoccupied by youth, looks on.

We leave her, the stick a third leg,
waiting to obey the gong,
(Saturday, boiled eggs for tea)
waiting for the rain to stop,
25 waiting for winter, waiting.

 Moira Andrew

Marks

Analysis

(a) By referring to the language of line 1, state what initial impression of the woman is conveyed. **2**

(b) What do lines 2–10 reveal to you about the woman's past circumstances?

Show how the language of these lines leads you to make three deductions about her past. **6**

(c) (i) Stanza three (lines 11–15) reveals aspects of the woman's personality. Suggest three characteristics of her personality. **3**

(ii) Go on to explain how effectively you think aspects of her personality are conveyed. You should refer to such techniques as word choice, sentence structure, imagery, sound . . . **3**

(d) From an examination of the language of lines 16–19 ("She waits defiantly . . . like unravelled knitting."), show how sympathy is elicited for the old woman. **3**

(e) "A man's face,
preoccupied by youth, looks on." (lines 19–20)

Comment on the significance of these lines in the context of the whole poem. **3**

Appreciation

(f) Comment on the significance for you of the idea of "waiting" in the whole poem. In your answer you should consider the poet's treatment of the idea and your reactions to it. **10**

Total Marks (30)

[Turn over for PART 2—CRITICAL ESSAY

PART 2—CRITICAL ESSAY

Attempt ONE question only, taken from any of the Sections A to D.

In all Sections you may use Scottish texts.

You should spend about 45 minutes on this part of the paper.

Begin your answer on a fresh page.

SECTION A—DRAMA

1. Choose a play in which a character is forced to compromise or refuses to compromise.

 Explain briefly how the situation comes about and go on to discuss how you think the character's decision affects the ideas and the outcome of the play.

 In your answer you must refer closely to the text and to at least two of: key scene(s), theme, climax, characterisation or any other appropriate feature.

2. Choose a play whose opening scene seems to you to be particularly amusing or menacing.

 Discuss how effectively the opening scene prepares you for the rest of the play.

 In your answer you must refer closely to the text and to at least two of: exposition, mood, setting, conflict, dialogue, theme or any other appropriate feature.

3. "I am . . . more sinned against than sinning."

 Discuss to what extent you find this an accurate description of a Shakespearean tragic hero or heroine.

 In your answer you must refer closely to the text and to at least two of: theme, characterisation, relationships, soliloquy, key scene(s), conflict or any other appropriate feature.

4. Choose a play in which tension is deliberately created towards the end.

 Explain how the tension is created and go on to discuss how the tension adds to your appreciation of the ending of the play.

 In your answer you must refer closely to the text and to at least two of: conflict, climax, dialogue, structure or any other appropriate feature.

SECTION B—PROSE

5. Choose a novel in which a character's personality appears to change.

 Outline the nature of the change (or the apparent change) and go on to discuss how this illuminates for you the theme(s) of the text.

 In your answer you must refer closely to the text and to at least two of: key incident(s), structure, narrative stance, contrast or any other appropriate feature.

6. Choose a novel in which symbolism plays an important part.

 Discuss how effectively the symbolism adds to your understanding and appreciation of the characterisation or the ideas in the novel.

 In your answer you must refer closely to the text and to at least two of: symbolism, characterisation, theme, setting, structure or any other appropriate feature.

7. Choose a novel or short story in which one character's loyalty or disloyalty to another proves to be decisive.

 Explain how this arises and go on to discuss why you think it is important to the text as a whole.

 In your answer you must refer closely to the text and to at least two of: key incident(s), characterisation, structure, narrative stance, tone or any other appropriate feature.

8. Choose a novel or a work of non-fiction whose setting contributes significantly to the overall impact of the text.

 Discuss the importance of the setting to your understanding and appreciation of the main concerns or issues of the text.

 In your answer you must refer closely to the text and to at least two of: setting, theme, style, symbolism or any other appropriate feature.

SECTION C—POETRY

9. Choose a poet whose work has impressed you in terms of both style and content.

 Referring to at least two poems, explain what you admire about the poet's work.

 In your answer you must refer closely to the text and to at least two of: theme, poetic form, imagery, word-choice or any other appropriate feature.

10. Choose a poem which forces you to face up to an unpleasant truth.

 Show how the poet achieves this effect.

 In your answer you must refer closely to the text and to at least two of: theme, word-choice, imagery, sound or any other appropriate feature.

11. Choose a poem which you think could be described as a love poem.

 Discuss how successfully the poet conveys the emotions in the poem.

 In your answer you must refer closely to the text and to at least two of: imagery, symbolism, poetic form, rhyme, rhythm or any other appropriate feature.

12. Choose a dramatic monologue which reveals a particularly admirable or particularly unpleasant character.

 Show how the poem leads you to form this opinion.

 In your answer you must refer closely to the text and to at least two of: poetic form, tone, setting, sound, word-choice or any other appropriate feature.

SECTION D—MASS MEDIA

13. Choose a film which leads you into the mind of a complex or subtle character.

 Explain how the character is created in this film.

 In your answer you must refer closely to the text and to at least two of: casting, dialogue, editing, use of camera, clothing, lighting or any other appropriate feature.

14. Choose a film which has something important to say to you about a serious social issue.

 Explain how the film conveys the importance of the subject.

 In your answer you must refer closely to the text and to at least two of: genre, theme, use of stars, setting, plot, key sequences or any other appropriate feature.

15. Isolation, rejection, confrontation, loneliness are major themes that are explored in many TV dramas.

 By referring to one TV drama, discuss how one of these themes is dealt with in a way which you found meaningful.

 In your answer you must refer closely to the text and to at least two of: theme, plot, use of camera, lighting, objects, colour, sound track or any other appropriate feature.

16. Many memorable TV dramas leave the viewer with a powerful impression of a person, a place, or an era.

 Describe how a TV drama succeeded in creating such an impression for you.

 In your answer you must refer closely to the text and to at least two of: genre, casting, colour, music, clothing, dialogue, properties or any other appropriate feature.

[END OF QUESTION PAPER]

X039/301

NATIONAL
QUALIFICATIONS
2000

WEDNESDAY, 24 MAY
9.00 AM – 10.30 AM

ENGLISH AND COMMUNICATION

HIGHER

Interpretation

You should attempt all questions.

The total value of the Paper is 60 marks.

PIB X039/301 6/3/9520

There are TWO passages and questions.

Read both passages carefully and then answer all the questions which follow. **Use your own words whenever possible and particularly when you are instructed to do so.**

You should read each passage to:

understand what each writer is saying about old age and society's attitudes towards old people (**Understanding—U**);

analyse each writer's choice of language, imagery and structures to recognise how they convey the point of view and contribute to the impact of the passage (**Analysis—A**);

evaluate how effectively each writer has achieved the purpose (**Evaluation—E**).

A code letter (U, A, E) is used alongside each question to give some indication of the skills being assessed. The number of marks attached to each question will give some indication of the length of answer required.

PASSAGE 1

In the first passage, Neil Ascherson, a distinguished journalist with "The Observer" newspaper, considers society's attitude towards old age and old people.

Last November 11th, old men and old women were doing what they are supposed to do best—remembering. They were 100 years old, more or less, as they stood or sat by the Cenotaph in
5 London and the Menin Gate at Ypres. They said: "Don't ever forget" and they were thinking of the millions who died young in the Great War. But it will be difficult to forget them either. They were few, but standing for the millions who are not dead
10 but simply old.

In a generation, living to 100 will be common. As the medical revolution of the twenty-first century replaces drugs with human spare parts grown from cell tissue, fit and mentally lively men and women
15 in their nineties will be common. Society is still utterly unprepared for this change. Chatter about "grey power", or even the growing and admirable concern for the old and helpless who are not cared for by families, have scarcely touched the problem.
20 The old, still veiled in outworn stereotypes and new-fangled prejudice, are the Great Excluded.

It is time to rewrite the Seven Ages of Man. When Shakespeare wrote about them, living beyond 60 was a rarity. Life was too short for what was
25 expected of human beings—not too long.

Now, though, the demographic tide is flowing in the opposite direction. In 1961, 6·2 million people in the United Kingdom were aged 65 or over. Today, it is nearly nine million; in 2021 it is
30 projected to be 11·7 million. The real leap here is at the top of the range: the proportion of those over 80. This group, which formed less than 2% in 1961, numbers about 4% now, but will reach 5% by 2021, when Britain will have about 30,000
35 centenarians. Life expectancy at birth was 58·4 years for men in 1931, and 62·4 years for women. Today, it is about 74 for men and almost 80 for women.

The figures don't add up to an unmixed disaster scenario. Unless the economy collapses, British 40 governments during the next generation can perfectly well afford to go on paying the present levels of state old-age pension, and could almost certainly afford to raise it in terms of real income. The problem here is political will rather than 45 financial capacity. The pinch will come in other resource areas, such as health spending. People over 65 consume three times as many prescription items as other age groups. Nearly half those with some measure of disability are over 70. 50

But the resource question, meeting the material needs of the old and elderly, is only half the story. The real problem lies elsewhere—in the imagination. What are the old for? Who are they, and do the traditional divisions of human life into 55 childhood, youth, middle age and old age still fit our experience?

You are not necessarily as old as you feel, but you are as old as other people feel you are. Age is a construct, a pattern woven by our society which 60 changes out of recognition as times change. For us, as for Shakespeare, male old age must imply the loss of physical beauty, the coming of "shrunk shanks", loose paunches and the rest.

In contrast, classical taste produced statuary 65 which showed old men with huge muscled shoulders, as if a life of physical labour left bodies more powerful than ever. Nothing remains of this view now; the idea of old men as images of strength rather than objects for "compassion" has become 70 repellent. When 1960s astronaut Senator John Glenn returned to space at the age of 77, he was celebrated as an exception to the rule. But when something happens which seems to challenge the general condescension towards the old, there is a 75 roar of virtuous disapproval from younger

generations.

Even the universal image of old age as the time of superior wisdom is passing away. We no longer have Elders whose counsel is precious and who must be respected. This debunking was already underway with Shakespeare's sardonic Seven Ages in *As You Like It*. For him, life after about 40 was already crumbling into absurdity. In our own times, grandmothers are still expected to remember—that much of their function remains—but their habit of giving advice, and requiring attention to be paid to their advice, is no longer wanted. The old have been excommunicated and they resent it.

47% of people over 75 live alone and frequently revert to their existence as teenagers. Their room is a tip of familiar possessions; they eat any old biscuits or cold sausages lying around; they delight in doing things their way; they have their own special circle of friends; they are usually deaf, but specially deaf to the scoldings of the authoritarian young. One day, society will realise this and invent a new purpose for the old. Until then, they must find their own reasons to survive.

PASSAGE 2

The second passage is taken from a collection of writing by mature women entitled "New Ideas for Getting the Most Out of Life". Here, Mary Cooper explains how and why she intends to continue to grow old "disgracefully".

How am I growing old disgracefully? Well, you wouldn't be shocked by my appearance if you met me in the street. And I wouldn't be likely to embarrass you if we stood talking.

For me growing old disgracefully is more an attitude to old age, a defying of its stereotypes, than an outrageous way of behaving. It is a necessary countering of the negative words and images associated with women's ageing: "old hag", "old bag", "old biddy" and so on.

It is OK for me now, for instance, to be an old woman on my own. It's true the world we know best is organised around couples, usually husband and wife, but there is a good life to be had as an old woman who is not part of a couple but who is part of a social network which includes a whole range of relationships.

When we are old there is more time for gossiping (men talk and discuss; women gossip, don't they?). I see old women together arm in arm negotiating a slippery pavement or rough steps. I see them with their trolleys gossiping together in the supermarket and I rejoice that we have each other, that the older we grow the more women of our own age there are around us. We are not going to be identified as "a growing social problem", as the social commentators would have us labelled, but as a thriving, gossiping and defiant sisterhood.

Yes, there is the fumbling, the constant mislaying of belongings, the forgetting of the right words and names but that happened when I was young too! Now I've got four competent daughters who enjoy putting me right. Now and again I want to remind them where I've been and what I've done with my life . . . "Never apologise! Never make excuses," I say to myself when this happens. "It only draws attention to the lapse. Move on to the next thing! If *they* still need to prove themselves, I don't." So I relax and resolve to remember the word—or whatever—next time and to have a laugh with my friends about it when we next meet.

Most of all, growing old disgracefully for me means that both the free, happy, playful child *and* the wise old woman are kept alive inside, both together, in my heart and in my head. This can't just happen; there have to be opportunities made and taken—joining in the silly games, or better still starting one off! And the wise old woman? I think the modern word for wisdom is self-awareness. And self-awareness, a critical self-awareness, is best kept alive by listening, by listening and learning—that will do for a start anyway.

Before I was a feminist, growing old disgracefully might have meant something quite different—being shameful, even wicked—at the very least, doing things my mother would have disapproved of! Now it means being more myself than I've ever been before! And that feels pretty good—most of the time!

I remember an occasion many years ago when my sister and I were watching an old fairground organ playing a waltz. We longed to dance together with the music but we were surrounded by our children. Their presence weighed us down. Then suddenly we both stepped into the open space in front of the organ, dancing together. It was a moment none of us has ever forgotten! So daring! So disgraceful! I cherish the memory; it holds the feeling I want to carry with me through my old age.

		Marks	Code

Questions on Passage 1

1. "Don't ever forget" (line 6)

 By referring to paragraph one, identify the two groups of people whom we should not forget. 2 U

2. "In a generation, living to 100 will be common." (line 11)

 (a) Explain fully the reason the writer gives for this statement. (Use your own words as far as possible in your answer.) 2 U

 (b) By referring to lines 15–21 ("Society is . . . Great Excluded."), explain fully the difficulties that such longevity causes. 2 U

3. "Now, though, the demographic tide is flowing in the opposite direction." (lines 26–27)

 (a) Analyse the image used by the writer in this sentence. 2 U/A

 (b) Show how effective you find the image in the context of lines 22–38. 2 E

4. "The figures don't add up to an unmixed disaster scenario." (lines 39–40)

 Explain the meaning of the sentence. Go on to explain how the ideas of the sentence are developed in the rest of the paragraph. 4 U

5. (a) In lines 51–57, identify **two** features of sentence structure which mark a shift in the writer's line of thought. 2 A

 (b) In your own words, explain this new line of thought. You should refer to lines 53–61 ("The real problem . . . as times change.") in your answer. 2 U

 (c) Show how the writer's use of imagery in lines 58–61 contributes to your understanding of this line of thought. 2 A

 (d) In lines 65–77, the writer refers to classical statuary and Senator John Glenn as evidence to illustrate his point about how we regard old age nowadays.

 How convincing do you find each of these illustrations? Justify your answers. 4 A/E

6. By referring to two examples from lines 78–90, show how the writer uses word choice to highlight his feelings about what has happened to old people. 4 A

7. Show how effective you find the ideas of the final paragraph (lines 91–100) as a conclusion to the passage as a whole. 4 E

Questions on Passage 2 (32)

8. From the opening paragraph (lines 1–4) identify **two** ways in which the writer gives the impression that she is addressing the reader directly. 2 A

9. Explain how the writer defines "growing old disgracefully" in the first sentence of paragraph two (lines 5–7). 3 U

10. How does the writer use sentence structure and punctuation in lines 18–28 to make clear her point of view? 4 A/U

11. What might be the question to which "Yes" (line 29) is the answer? 1 U

12. What is suggested about the writer's relationship with her daughters? You should refer closely to lines 29–41 in your answer. 4 U/A

13. In the last three paragraphs of the passage (lines 42–69), the writer provides more answers to her original question "How am I growing old disgracefully?" Briefly summarise the main point(s) made in each paragraph. 6 U

Questions on both Passages (20)

14. (a) Identify the overall tone of each of the passages and say what effect the tone of each had on your appreciation of the passages. 4 E/A

 (b) By close reference to both passages, compare and contrast other aspects of the style of writing of each passage and say how successful you felt each was in conveying the point of view of the writer.

 You should consider such aspects as punctuation, sentence structure, word-choice, use of examples, or any other feature. You must not consider tone. 4 E/A

[END OF QUESTION PAPER] (8)

Total (60)

X039/302

NATIONAL
QUALIFICATIONS
2000

WEDNESDAY, 24 MAY
10.50 AM – 12.20 PM

ENGLISH AND COMMUNICATION
HIGHER
Analysis and Appreciation

There are **two parts** to this paper and you should attempt both parts.

Part 1 (Textual Analysis) is worth 30 marks.

In Part 2 (Critical Essay), you should attempt **one** question only, taken from any of the Sections A–D.

Your answer to Part 2 should begin on a fresh page.

Each question in Part 2 is worth 30 marks.

NB You must not use, in Part 2 of this paper, the same text(s) as you have used in your Specialist Study.

SCOTTISH
QUALIFICATIONS
AUTHORITY

PART 1—TEXTUAL ANALYSIS

Read the following poem and answer the questions which follow.

You are reminded that this part of the paper tests your ability to understand, analyse and evaluate the text.

The number of marks attached to each question will give some indication of the length of answer required.

You should spend about 45 minutes on this part of the paper.

TIMETABLE

We all remember school, of course:
the lino warming, shoe bag smell, expanse
of polished floor. It's where we learned
to wait: hot cheeked in class, dreaming,
5 bored, for cheesy milk, for noisy now.
We learned to count, to rule off days,
and pattern time in coloured squares:
purple English, dark green Maths.

We hear the bells, sometimes,
10 for years, the squeal and crack
of chalk on black. We walk, don't run,
in awkward pairs, hoping for the open door,
a foreign teacher, fire drill. And love
is long aertex summers, tennis sweat,
15 and somewhere, someone singing flat.
The art room, empty, full of light.

 Kate Clanchy

QUESTIONS

Marks

1. What effect does "of course" have on your reading of the first line? 1

2. Show how the poet evokes a vivid picture of school in lines 2–5. 4

3. What attitude about the writer's time in school seems to emerge in lines 6–8? Justify your answer by referring closely to the content and techniques of these lines. 4

4. In what way do lines 9–10 link the ideas of verses one and two? 2

5. Show how the poet uses sound to enhance the mood in the first sentence of the second verse (lines 9–11). 4

6. ". . . hoping for the open door,
 a foreign teacher, fire drill." (lines 12–13)

 (*a*) Why might each of these be hoped for? 3

 (*b*) In what way does the idea suggested by these things contrast with
 ". . . We walk, don't run,
 in awkward pairs . . ." (lines 11–12)? 2

7. In the final lines, the writer refers to tennis, singing and the art room. What do any **two** of these references contribute to the mood of the final part of the poem? 4

8. What do you see as the relationship between the title of the poem and:

 (*a*) verse one;

 (*b*) verse two? 6

Total (30)

[Turn over for PART 2—CRITICAL ESSAY

PART 2—CRITICAL ESSAY

Attempt ONE question only, taken from any of the Sections A to D. Write the number of the question you attempt in the margin of your answer book.

In all Sections you may use Scottish texts.

You must not use the poem from the Textual Analysis part of the paper as the subject of your Critical Essay.

You are reminded that the quality of your writing and its accuracy are important in this paper as is the relevance of your answer to the question you have attempted.

You should spend about 45 minutes on this part of the paper.

Begin your answer on a fresh page.

SECTION A—DRAMA

1. Choose a play which is based partly or wholly on historical events.

 Discuss to what extent, in your opinion, the play retains its relevance in the modern world.

 In your answer you must refer closely to the text and to at least two of: theme, setting, characterisation, key scene(s), or any other appropriate feature.

2. Choose a play in which the deterioration of a marriage or a relationship is important.

 Show how the dramatist presents the deterioration, and why it is, in your opinion, important to the play as a whole.

 In your answer you must refer closely to the text and to at least two of: characterisation, theme, dialogue, plot, conflict, or any other appropriate feature.

3. Choose a play with a clear political or social or religious message.

 Outline briefly what the "message" is and go on to explain the methods by which the dramatist makes you aware of it.

 In your answer you must refer closely to the text and to at least two of: theme, characterisation, setting, dramatic style, or any other appropriate feature.

4. Choose a play in which one speech or piece of dialogue is particularly important.

 Put the speech or piece of dialogue in context, and then go on to explain why you think it is particularly important to the rest of the play.

 In your answer you must refer closely to the text and to at least two of: characterisation, theme, language, climax, or any other appropriate feature.

SECTION B—PROSE

5. Choose a novel or short story in which an element of mystery plays an important part.

 Show how the development and resolution of the mystery contributed to your enjoyment of the text as a whole.

 In your answer you must refer closely to the text and to at least two of: atmosphere, key incident(s), plot, narrative stance, setting, or any other appropriate feature.

6. Choose a novel which you think has a definite turning point or decisive moment.

 Explain briefly what happens at that point or moment and go on to explain why you think it is so important to the rest of the novel.

 In your answer you must refer closely to the text and to at least two of: key incident(s), structure, plot, theme, characterisation, or any other appropriate feature.

7. Choose a work of non-fiction which had a powerful impact on you.

 Show how the writer managed to achieve this effect.

 In your answer you must refer closely to the text and to at least two of: language, point of view, theme, structure, mood, or any other appropriate feature.

8. Choose a novel or short story in which humour plays an important part.

 Explain how the humour is created and show how it made an important contribution to your enjoyment of the text as a whole.

 In your answer you must refer closely to the text and to at least two of: characterisation, dialogue, key incident(s), style, or any other appropriate feature.

SECTION C—POETRY

(In this section you may not answer using "Timetable" by Kate Clanchy)

9. Choose a poem about old age.

 Explain what impression the poet creates of old age and discuss how effectively the impression is created.

 In your answer you must refer closely to the text and to at least two of: theme, imagery, word choice, structure, mood, or any other appropriate feature.

10. Choose two poems which deal with the same theme.

 By referring to both poems, show which you find more effective in dealing with the theme.

 In your answer you must refer closely to the text and to at least two of: theme, structure, word choice, imagery, or any other appropriate feature.

11. Choose a poem which you think could be described as a "quiet" or a "reflective" poem.

 Show how the poet has achieved this effect and discuss to what extent you find it a suitable way of dealing with the subject matter in the poem.

 In your answer you must refer closely to the text and to at least two of: mood, theme, sound, imagery, rhythm, or any other appropriate feature.

12. Choose a poem with an impressive opening.

 Explain why you think the opening was so impressive and discuss how effectively it prepared you for the rest of the poem.

 In your answer you must refer closely to the text and to at least two of: theme, imagery, sound, development, form, or any other appropriate feature.

[Turn over

SECTION D—MASS MEDIA

13. Choose a film or TV drama which is based partly or wholly on historical events.

 Discuss to what extent, in your opinion, the film or TV drama retains its relevance in the modern world.

 In your answer you must refer closely to the text and to at least two of: setting, theme, sound track, aspects of mise-en-scène such as costume and objects, or any other appropriate feature.

14. Choose a TV drama or documentary with a clear political or social or religious message.

 Outline briefly what the "message" was and go on to explain the methods by which the writer and/or director made you aware of it.

 In your answer you must refer closely to the text and to at least two of: theme, point of view, casting, editing, aspects of mise-en-scène such as use of camera, or any other appropriate feature.

15. Choose a film or TV drama in which an element of mystery plays an important part.

 Show how the development and resolution of the mystery contributed to your enjoyment of the text as a whole.

 In your answer you must refer closely to the text and to at least two of: characterisation, plot, editing, aspects of mise-en-scène such as use of camera and lighting, or any other appropriate feature.

16. Choose a film which you think has a definite turning point or decisive moment.

 Explain briefly what happens at that point or moment and go on to explain why you think it is so important to the rest of the film.

 In your answer you must refer closely to the text and to at least two of: plot, editing, sound track, aspects of mise-en-scène such as lighting and use of camera, or any other appropriate feature.

[END OF QUESTION PAPER]

X039/301

NATIONAL QUALIFICATIONS 2001

TUESDAY, 15 MAY 9.00 AM – 10.30 AM

ENGLISH AND COMMUNICATION
HIGHER
Close Reading

You should attempt all questions.

The total value of the Paper is 60 marks.

There are TWO passages and questions.

Read both passages carefully and then answer all the questions which follow. **Use your own words whenever possible and particularly when you are instructed to do so.**

You should read each passage to:

understand what the authors are saying about Muhammed Ali (**Understanding—U**);

analyse their choices of language, imagery and structures to recognise how they convey their points of view and contribute to the impact of the passages (**Analysis—A**);

evaluate how effectively each writer has achieved his purpose (**Evaluation—E**).

A code letter (U, A, E) is used alongside each question to give some indication of the skills being assessed. The number of marks attached to each question will give some indication of the length of answer required.

SCOTTISH
QUALIFICATIONS
AUTHORITY

PASSAGE 1

Journalist, Ian Wooldridge, reflects on the life of Muhammed Ali in an article which appeared in the British Airways magazine High Life *in 2000. It is slightly adapted.*

THE GREATEST VICTIM

I first set eyes on Muhammed Ali in the beautiful Palazzo dello Sport in Rome on a September evening in 1960. His name then was Cassius Clay. He was 18 years old, incredibly handsome, about
5 to fight for the Olympic light-heavyweight title and looked scared of nothing. This was the first of a myriad of misconceptions and contradictions about the extraordinary man, who 40 years later was overwhelmingly voted the greatest sportsman
10 of the 20th century.

The truth was that he was dead scared of flying. Two months earlier, on his way to the U.S. boxing trials, he had been violently buffeted during a turbulent flight across to California. It was the
15 first time he had travelled by air and he swore he would never fly again. This was marginally inconvenient when he was one of the hottest hopes America had for Olympic boxing gold. It took hours of persuasion and cajolery to talk him back
20 on to the plane to Italy.

I have often wondered whether the world would have heard of him had he dug his heels in on the day of departure. Probably not. In 1960, in racist, reactionary, bigoted small-town America, uppity
25 young black men were lucky enough to get one break, let alone two.

Destiny determined otherwise. A legend was in the making. What overwhelms you about this man from such a violent trade are the goodness,
30 sincerity and generosity that have survived a lifetime of controversy, racial hatred, fundamental religious conversion, criminal financial exploitation, marital upheavals, revilement by many of his own nation and, eventually, the
35 collapse of his own body.

Little did I visualise, 37 years after that Roman evening, I would meet him again and be reduced to tears. The supreme athlete and unique showman once deemed by *Time* magazine to be the most
40 instantly recognised human being in the world, struggled up from a settee, tottered unsteadily across the carpet and embraced me in an enveloping bear-hug. Facially bloated, he could speak only in brief, almost unintelligible gasps.
45 Reminiscence was impossible. He smiled a lot, but he suffers from narcolepsy as well as the brain damage which some have identified as Parkinson's disease. Every few minutes he slept while his fourth wife, Lonnie, took over the conversation. A
50 little girl in 1960, living in the same street as the Olympic hero and holding a torch for him, she stepped in thirty years later when, health gone and

asset-stripped by rapacious promoters, he was on the skids.

How did Ali, the icon of world sport, come to this? 55 It was a cavalier attitude to money when it was plentiful, an almost childlike trust in the untrustworthy and, throughout, an utterly reckless generosity. One fight I attended in Kuala Lumpur, Malaysia, showed a fascinating insight 60 into how the money haemorrhaged. He was accompanied by a retinue of 44, of whom perhaps six were professionally involved. The rest were relatives, friends of relatives, old pals of Ali who had fallen on hard times, and outright leeches. 65 Daily they plundered the hotel's shopping mall amassing clothes, jewellery and tacky souvenirs, all charged to Ali's account. But there were also altruistic courtiers. Two days before the fight, I was visited by one Charlie Perkins, an ex-Everton 70 footballer I knew slightly. He is an Australian Aborigine, extremely articulate and an evangelist for Aboriginal rights. Charlie had a simple objective—to persuade Ali to fly down to Australia and throw his personality and enormous influence 75 behind their cause. Ali was sympathetic but, no, he would not proceed to Australia. What he did was to put Perkins (and his companions) on his payroll in some spurious capacity and pick up the tab for their airfares back to Sydney. He never met them again. 80 And mainstream America's rejection? He was a national hero on his return to Louisville from his Olympic triumph, but there were still those who called him "boy" and restaurants which didn't admit blacks. Disillusioned, his riposte was 85 to jettison the name Cassius Clay, handed down from the slave owners of his African forebears, and become Muhammed Ali, pilgrim of Mecca, convert to the Muslim faith. It was a predictable decision but one which was to bring opprobrium 90 upon him nationwide. To much of middle-class America he was now a renegade and soon became a pariah when he refused the draft to fight for his country in Vietnam. "I ain't got no quarrel with them Vietcong," he said, and was subsequently, at the 95 peak of his career, banned from boxing for four years.

I am not a boxing expert. Those who are, mostly endorse Muhammed Ali's opinion of himself at his peak: "The Greatest." But it took a long time for 100 mainstream America to become reconciled to that judgement. For many, he was a turbulent, disturbing figure who challenged homespun values.

105 But then eventually there came a night when he won over most of the remaining doubters. It was the best kept secret of the 1996 Olympic Games in Atlanta, at the very heart of America's Deep South, when he emerged high in the tower of the stadium, to extend

110 a trembling arm and apply, just, a flaming torch to light the Olympic cauldron.

Three years later, he was honoured as the Sports Personality of the Millennium, and we held our breath as he struggled with a few words to an

115 adoring audience. The following evening at a dinner, I sat next to him. Having met everyone in the room, he slumbered throughout most of the proceedings. But I had learned to cope with it now, knowing that in his waking moments he could understand everything you said while unable to reply 120 coherently. I had left a pen lying on the table. Ali picked it up and began to doodle on the linen cloth with nursery drawings. "Skyscraper," he whispered. "Airplane." There were six or seven of them and when he'd finished we whipped the cloth from the 125 table and auctioned it on the spot for £10,300 for charity. Muhammed Ali beamed at that. The man who had let millions slip through his fingers knew he was still helping those even less fortunate than himself. 130

PASSAGE 2

The passage is adapted from the introduction to I'm a Little Special—a Muhammed Ali Reader. *Gerald Early considers his feelings in the 1960s about his boyhood hero.*

THE GREAT ALI

I was no good at wood-working and the like, so I saved my paper route money, and simply bought a baseball bat, a genuine Louisville Slugger, the first one I ever owned. I sanded that bat, re-stained it

5 dark, gave it a name. I carved, scratched really, into the bat the word, *Ali*. I tried to carve a lightning bolt but my limited artistic skill would not permit it. I wanted to carry it in a case but I didn't have one. I just slung it over my shoulder like the great

10 weapon it was, my knight's sword. And I felt like some magnificent knight, some great protector of honour and virtue, whenever I walked on the field.

I used that bat the entire summer and a magical season it was. I was the best hitter in the

15 neighbourhood. Once, I won a game in the last at-bat with a home run, and the boys just crowded round me as if I were a spectacle to behold, as if I were, for some small moment, in this insignificant part of the world, playing this meaningless game,

20 their majestic, golden prince.

But, the bat broke. Some kid used it without my permission. He hit a foul ball and the bat split, the barrel flying away, the splintered handle still in the kid's hands.

25 That was 1966 and Muhammed Ali seemed not simply the best boxer of the day but the best boxer who could possibly be imagined—so good that it was an inspiration to see even a picture of him. My body shivered when I saw him as if an electric shock

30 had pulverised my ability to feel. No fighter could touch him. His self-knowledge was glorious, so transcendently fixed was he on the only two subjects he knew: himself and boxing. He so filled me with his holy spirit that whenever, late in a game, our side needed a rally, I would call out Ali's 35 chant to my teammates, "Float like a butterfly sting like a bee!" That made little sense metaphorically in relation to baseball, but it seemed to work more often than not. It was for me, the summer of 1966, Ali's absolute moment of 40 black possibilities fulfilled. And I wanted that and had it for a moment, too, had it, perhaps, among the neighbourhood guys, the touch and glory of the great Ali.

When the bat broke, it seemed a certain spell was 45 broken, too. I drifted away from baseball by steps and bounds. The next summer, 1967, Ali was convicted of draft-dodging. Martin Luther King came out against the Vietnam War. Baseball did not seem very important. Something else was. For you 50 see, I could never be sure, before that spring when Ali first refused to be drafted, if in the end he really would refuse an unjust fight. So when he did finally refuse, I felt something greater than pride: I felt as though my honour as a black boy had been 55 defended, my honour as a human being. He was the grand knight, after all, the dragon-slayer. And I felt myself, little inner-city boy that I was, his apprentice to the grand imagination, the grand daring. The day that Ali refused the draft, I cried in 60 my room. I cried for him and for myself, for my future and his, for all our black possibilities. If only I could sacrifice like that, I thought. If only I could sacrifice my life like Muhammed Ali . . .

Questions on Passage 1

Marks *Code*

1. (a) By referring to lines 1–6 ("I first . . . scared of nothing."), briefly explain two things which attracted the writer to Cassius Clay. Use your own words as far as possible in your answer.

2 U

 (b) Briefly explain the "first" (line 6) contradiction about Cassius Clay referred to in lines 6–11 ("This was . . . of flying.").

1 U

 (c) "This was marginally inconvenient . . . boxing gold." (lines 16–18)

 What tone is adopted by the writer in this sentence? Go on to explain briefly how effective you find this tone in the context.

2 A/E

2. Look at lines 21–35.

 (a) Explain what the writer means by "Destiny determined otherwise." (line 27)

2 U

 (b) Show how the writer uses sentence structure in lines 21–35 to dramatise his view about destiny and Muhammed Ali.

4 A

3. By referring to lines 36–44, show how the writer uses contrast to convey his shock at meeting Muhammed Ali years later.

2 A

4. (a) Explain in your own words two reasons for Muhammed Ali's poverty. In your answer, you should refer to lines 55–59 ("How did . . . reckless generosity.").

2 U

 (b) Show how effective you find the writer's use of imagery to convey his feelings about what happened to Muhammed Ali's money. In your answer, you should analyse two examples from lines 59–68 ("One fight . . . Ali's account.").

4 A/E

 (c) What makes Charlie Perkins's motives different from those of Ali's other "courtiers" (line 69)?

2 U

5. Summarise the main reasons for "mainstream America's rejection" of Muhammed Ali. You should refer to lines 81–104 in your answer and use your own words as far as possible.

5 U

6. Show how **either** of the final two paragraphs effectively illustrates both the "triumph" and the "tragedy" of Muhammed Ali. You should refer to content and style in your answer.

4 A/E

(30)

Questions on Passage 2

7. (a) By referring to lines 1–8 ("I was . . . have one."), briefly explain how any two of the writer's actions show the importance of the baseball bat to him.

2 U

 (b) Show how the writer uses imagery in lines 9–20 ("I just . . . golden prince.") to convey how the bat affected the way he thought about himself. You should refer to two examples in your answer.

4 A

8. Show how the writer's language in lines 21–24 conveys the impact of the destruction of his bat.

2 A

9. By referring to lines 25–44, show how the writer uses word choice to convey the intensity of his feelings about Muhammed Ali.

4 A

10. (a) By referring to the final paragraph (line 45 to the end) explain fully why Muhammed Ali's refusal to fight in the Vietnam War was so significant to the writer.

4 U

 (b) Show how the writer's language in the final paragraph conveys the passion he felt about Ali's decision not to fight in the Vietnam War. In your answer, you should refer to more than one of the following: imagery, sentence structure, punctuation, word choice.

4 A

(20)

Questions on both Passages

11. (a) From your reading of both passages, what do you think are the key reasons for Muhammed Ali's "greatness"?

5 U

 (b) Which writer's style do you prefer?

 Justify your view by referring to both passages and to such features as structure, anecdote, symbolism, imagery, word choice . . .

5 A/E

[END OF QUESTION PAPER]

Total (60)

X039/302

NATIONAL
QUALIFICATIONS
2001

TUESDAY, 15 MAY
10.50 AM – 12.20 PM

ENGLISH AND COMMUNICATION

HIGHER

Analysis and Appreciation

There are **two parts** to this paper and you should attempt both parts.

Part 1 (Textual Analysis) is worth 30 marks.

In Part 2 (Critical Essay), you should attempt **one** question only, taken from any of the Sections A–D.

Your answer to Part 2 should begin on a fresh page.

Each question in Part 2 is worth 30 marks.

> NB You must not use, in Part 2 of this paper, the same text(s) as you have used in your Specialist Study.

SCOTTISH
QUALIFICATIONS
AUTHORITY

©

PART 1—TEXTUAL ANALYSIS

Read the following poem and answer the questions which follow.

You are reminded that this part of the paper tests your ability to understand, analyse and evaluate the text.

The number of marks attached to each question will give some indication of the length of answer required.

You should spend about 45 minutes on this part of the paper.

In this poem "Originally" by Carol Ann Duffy, the initial situation seems to picture a family journey or move from one town to another.

ORIGINALLY

We came from our own country in a red room
which fell through the fields, our mother singing
our father's name to the turn of the wheels.
My brothers cried, one of them bawling *Home,*
5 *Home,* as the miles rushed back to the city,
the street, the house, the vacant rooms
where we didn't live any more. I stared
at the eyes of a blind toy, holding its paw.

All childhood is an emigration. Some are slow,
10 leaving you standing, resigned, up an avenue
where no one you know stays. Others are sudden.
Your accent wrong. Corners, which seem familiar,
leading to unimagined, pebble-dashed estates, big boys
eating worms and shouting words you don't understand.
15 My parents' anxiety stirred like a loose tooth
in my head. *I want our own country,* I said.

But then you forget, or don't recall, or change,
and, seeing your brother swallow a slug, feel only
a skelf of shame. I remember my tongue
20 shedding its skin like a snake, my voice
in the classroom sounding just like the rest. Do I only think
I lost a river, culture, speech, sense of first space
and the right place? Now, *Where do you come from?*
strangers ask. *Originally?* And I hesitate.

Carol Ann Duffy

QUESTIONS

1. (*a*) The poet seems to be moving to a different part of the country. What do you think is the
 mood in the first three lines of the poem? Briefly justify your answer. 2

 (*b*) Explain in detail how a contrast is created between the poet and her brothers in the rest of
 verse one (lines 4–8). 3

2. (*a*) "All childhood is an emigration." (line 9)

 What do you think this line means? 2

 (*b*) "Some are slow," (line 9) "Others are sudden" (line 11).

 Show how the poet highlights features of each emigration in lines 9–14. You should refer to
 word choice, sentence structure and sound in your answer. 6

3. "My parents' anxiety stirred like a loose tooth in my head. *I want our own country*, I said."
 (lines 15–16)

 (*a*) Why might the parents be anxious? 1

 (*b*) How effective do you find the image in this context (lines 15–16)? 2

4. Explain how the language of lines 17–21 helps you to appreciate the change introduced by the
 word "But". 4

5. How do the ideas of the last section of the poem from "Do I only . . ." (line 21 to the end) justify
 the choice of "Originally" as the title of the poem? 4

6. What do you think is an important theme in this poem? How effectively do you feel the poem
 has explored this theme?

 You may wish to consider such language features as imagery, tone, point of view, enjambement,
 structure of the poem . . . 6

 (30)

[Turn over for PART 2—CRITICAL ESSAY

PART 2—CRITICAL ESSAY

Attempt ONE question only, taken from any of the Sections A to D. Write the number of the question you attempt in the margin of your answer book.

In all Sections you may use Scottish texts.

You must not use the poem from the Textual Analysis part of the paper as the subject of your Critical Essay.

You are reminded that the quality of your writing and its accuracy are important in this paper as is the relevance of your answer to the question you have attempted.

You should spend about 45 minutes on this part of the paper.

Begin your answer on a fresh page.

SECTION A—DRAMA

1. Choose a play in which a character makes a brave decision.

 Briefly explain the circumstances which lead up to the decision and then discuss how it affects your views of the character.

 In your answer you must refer closely to the text and to at least two of: characterisation, key scene, theme, dialogue, or any other appropriate feature.

2. Choose a play whose main theme you feel is important to you personally.

 Show how the dramatist explores the theme and discuss to what extent the play influenced your views.

 In your answer you must refer closely to the text and to at least two of: theme, setting, conflict, key scene(s), or any other appropriate feature.

3. Choose from a play a scene in which one character makes an accusation against another character.

 Explain the dramatic importance of the scene and discuss how it affects your sympathy for either or both of the characters.

 In your answer you must refer closely to the text and to at least two of: dialogue, key scene, characterisation, theme, or any other appropriate feature.

4. Choose from a play a scene in which you felt totally involved (either as an audience member at a performance, or as a reader).

 Show how the skill of the dramatist or of those making the performance caused you to be so involved.

 In your answer you must refer closely to the text and to at least two of: theme, characterisation, stage directions, aspects of staging such as lighting, sound, movement, costume, or any other appropriate feature.

SECTION B—PROSE

5. Choose a novel which explores the nature of evil.

 Show how the writer's exploration of the theme enhanced your understanding of evil.

 In your answer you must refer closely to the text and to at least two of: theme, setting, symbolism, characterisation, or any other appropriate feature.

6. Choose a novel or short story in which the method of narration makes a major contribution to its impact.

 Describe the method of narration and explain why you feel it makes a major contribution to your appreciation of the text as a whole.

 In your answer you must refer closely to the text and to at least two of: narrative technique, theme, language, structure, or any other appropriate feature.

7. Choose a **non-fiction text** in which the writer's attention to detail is an important factor.

 Illustrate the writer's skill in this area and explain why you feel it makes a major contribution to your appreciation of the text as a whole.

 In your answer you must refer closely to the text and to at least two of: style, ideas, point of view, setting, anecdote, or any other appropriate feature.

8. Choose a novel or short story which is set in the past.

 Discuss to what extent, despite the distance in time, you were engaged by the actions and beliefs of one of the characters.

 In your answer you must refer closely to the text and to at least two of: setting, characterisation, key incident(s), theme, or any other appropriate feature.

SECTION C—POETRY

In this Section you may not answer using "Originally" by Carol Ann Duffy

9. Choose a poem which creates a sense of menace.

 Show how the poet achieves this and discuss how it adds to your appreciation of the poem.

 In your answer you must refer closely to the text and to at least two of: mood, theme, imagery, sound, or any other appropriate feature.

10. Choose a poem on the subject of love.

 Show how the poet treats the subject, and explain to what extent you find the treatment convincing.

 In your answer you must refer closely to the text and to at least two of: theme, imagery, form, tone, or any other appropriate feature.

11. Choose a poet who reflects on the idea of change.

 Show how the poet explores the subject in one or more of his/her poems, and explain to what extent your appreciation of the subject was deepened.

 In your answer you must refer closely to the text and to at least two of: theme, structure, imagery, tone, or any other appropriate feature.

12. Choose a poem which is written in a specific poetic form, such as dramatic monologue, sonnet, ode, ballad.

 Show how the particular form helped your appreciation of the ideas and/or feelings which the poem explores.

 In your answer you must refer closely to the text and to at least two of: form, theme, rhythm and rhyme, imagery, or any other appropriate feature.

[Turn over

SECTION D—MASS MEDIA

13. Choose a film or TV drama* in which a character makes a brave decision.

Briefly explain the circumstances which lead up to the decision and then discuss how it affects our views of the character.

In your answer you must refer closely to the text and to at least two of: key scene, dialogue, casting, aspects of mise-en-scène such as lighting and use of camera, or any other appropriate feature.

14. Choose a TV drama* whose main theme you feel is important to you personally.

Show how the dramatist explores the theme and discuss to what extent the text influenced your views.

In your answer you must refer closely to the text and to at least two of: theme, setting, conflict, montage, sound, or any other appropriate feature.

15. Choose a film or TV drama* which is set in the past.

Discuss to what extent, despite the distance in time, you were engaged by the actions and beliefs of one of the characters.

In your answer you must refer closely to the text and to at least two of: setting, characterisation, key sequence(s), aspects of mise-en-scène such as costume and props, or any other appropriate feature.

16. Choose a film which creates a sense of menace.

Show how the film-makers achieve this and discuss how it adds to your appreciation of the film.

In your answer you must refer closely to the text and to at least two of: mood, montage, sound, aspects of mise-en-scène such as lighting and use of camera, or any other appropriate feature.

*"TV drama" may be a single play, series or serial.

[END OF QUESTION PAPER]